# EDWARD
# HOPPER

## AN AMERICAN MASTER

ITA G. BERKOW

# TODTRI

This book was designed and produced by
TODTRI Book Publishers
Fax : (212) 695-6984
e-mail : info@todtri.com

Printed and bound in Indonesia

ISBN 1-880908-48-4
Visit us on the web!
www.todtri.com

Author: Ita G. Berkow

*Publisher:* Robert M. Tod
*Book Designer:* Mark Weinberg
*Production Coordinator:* Heather Weigel
*Project Editor:* Edward Douglas
*Editor:* Linda Greer
*Picture Researcher:* Ede Rothaus
*Typesetting:* Command-O, NYC

## SELECTED BIBLIOGRAPHY

Barr, Alfred H., Jr. *Edward Hopper: Retrospective Exhibition. New York*: The Museum of Modern Art, 1933.

du Bois, Guy Pene. "The American Paintings of Edward Hopper." *Creative Art*, 8 (March 1931), 187-91.

Goodrich. Lloyd. *Edward Hopper: Exhibition and Catalogue.* New York: Whitney Museum of American Art, 1964.

Goodrich, Lloyd. *Edward Hopper.* New York: Harry N. Abrams, 1971.

Hobbs, Robert. *Edward Hopper.* New York: Harry N. Abrams, Inc., Publishers in association with the
National Museum of American Art, Smithsonian Institution, 1987.

Kuh, Katherine. *The Artist's Voice: Talks with Seventeen Artists.* New York: Harper and Row. 1962.

Levin, Gail. *Edward Hopper as Illustrator.* New York: W. W. Norton & Company in association with the Whitney Museum of American Art, 1979.

Levin, Gail. "Edward Hopper's 'Office at Night'." *Arts Magazine*, 53 (June 1979), pp. 114-21.

Levin, Gail. *Edward Hopper: The Art and Artist.* New York: W. W. Norton & Company in association with the Whitney Museum of American Art, 1980.

O'Doherty, Brian. "Portrait: Edward Hopper," *Art in America*, 52 (December 1964), pp. 68-88.

Tyler, Parker. "Edward Hopper: Alienation by Light." *Magazine of Art*, 41 (December 1948), pp. 290-95.

Todd, Ellen Wiley. "Will (S)he Stoop to Conquer? Preliminiaries Toward a Reading of Edward Hopper's Office at Night." Norman Bryson et al.,
eds. *Visual theory. Painting and Interpretation.* New York: Icon Editions, 1991.

# CONTENTS

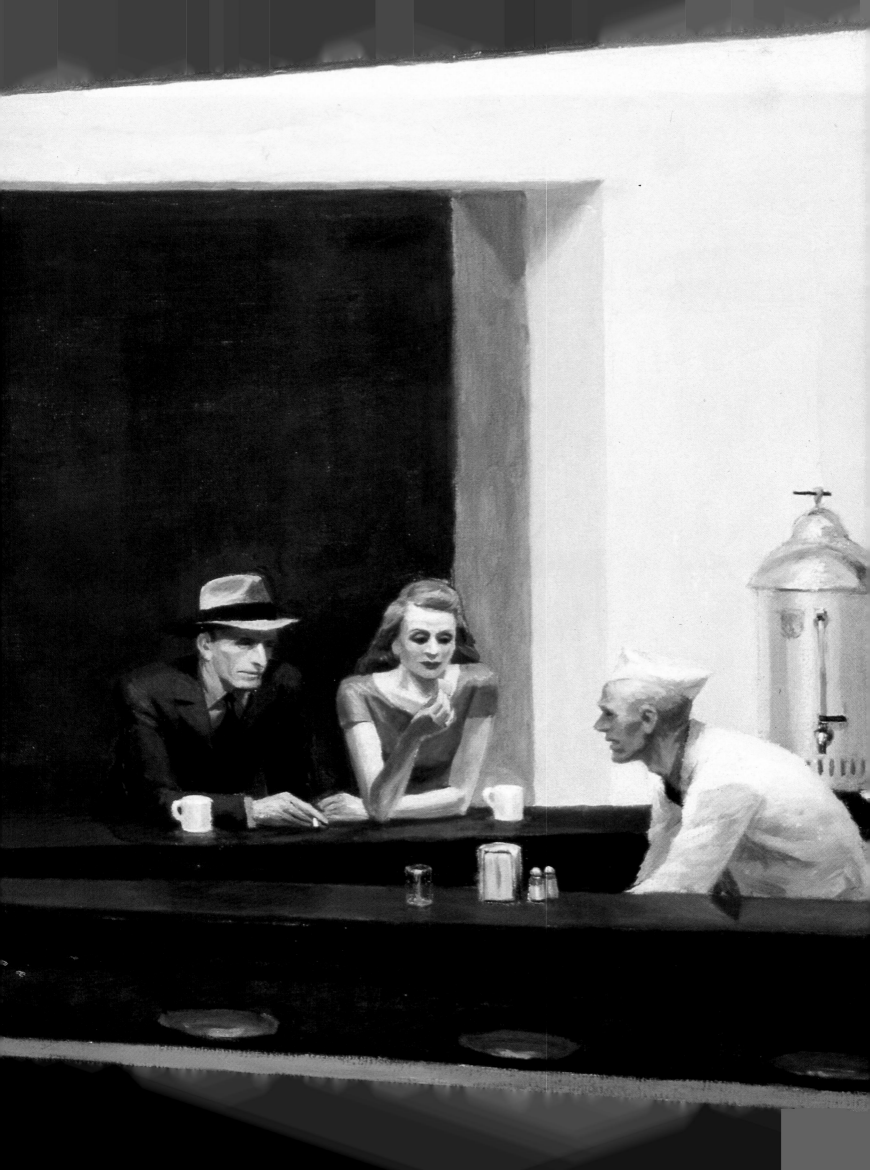

# INTRODUCTION

**O**ne does not need to be an aficionado of American Art to be familiar with Edward Hopper. Similar to the works of the European impressionists, Hopper's paintings are some of the most well-liked American paintings of the twentieth century. Indeed, his images of city life have garnered such popularity that many have become icons of American pop culture. For example, *Nighthawks* (1942), an image of a diner at night, has been used repeatedly for commercial purposes. The best-selling contemporary poster *Boulevard of Broken Dreams* is an exact replica of *Nighthawks* except for one alteration: the four anonymous figures in the diner have been replaced by Marilyn Monroe, Humphrey Bogart, James Dean, and Elvis Presley. A more recent appropriation of *Nighthawks* can be found on the promotional mugs for Starbucks coffee company. In a clever marketing move, Starbucks replaced the lettering on the diner's storefront sign, which originally said "Phillies," with the words "Starbucks Coffee."

Hopper's art may have influenced film images as well. Similarities have been noted between Hopper's art and the *film noir* style, and both film and art critics are still debating whether Hopper's art was influenced by or was an influence for *film noir*. Most likely, it was a little bit of both. Hopper's work, however, plainly influenced the famous director Alfred Hitchcock. In Hitchcock's thriller *Psycho*, released in 1960, the house in which the killer, Norman Bates, resides is remarkably similar to the house in Hopper's *House by Railroad*, which was painted in 1925. Furthermore, Hitchcock was known to be a great fan of Hopper's art.

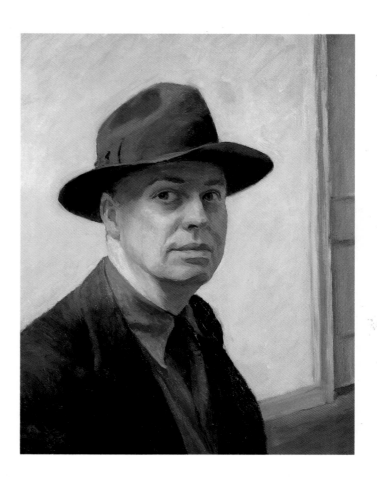

**Nighthawks**
*detail; 1942; oil on canvas; The Art Institute of Chicago*
In Hopper's ledger book, the man holding the cigarette is referred to as a nighthawk, explaining the origin of the painting's title. In a preliminary sketch for the piece, the man and his female companion are engaged in conversation. However, in the final work there is no communication between them and both stare into the distance.

**Self-Portrait**
*1925-30, oil on canvas; 25 1/16 x 20 3/8 in. (64 x 52 cm).*
*Collection of Whitney Museum of American Art, New York.*
Success for Hopper came late in life. When critical recognition finally arrived, Hopper was well into his forties. Of the many self-portraits he painted, this one seems to characterize the artist's unsureness of his newfound success. Even late in life, after becoming an established icon in American art, the artist feared bad reviews.

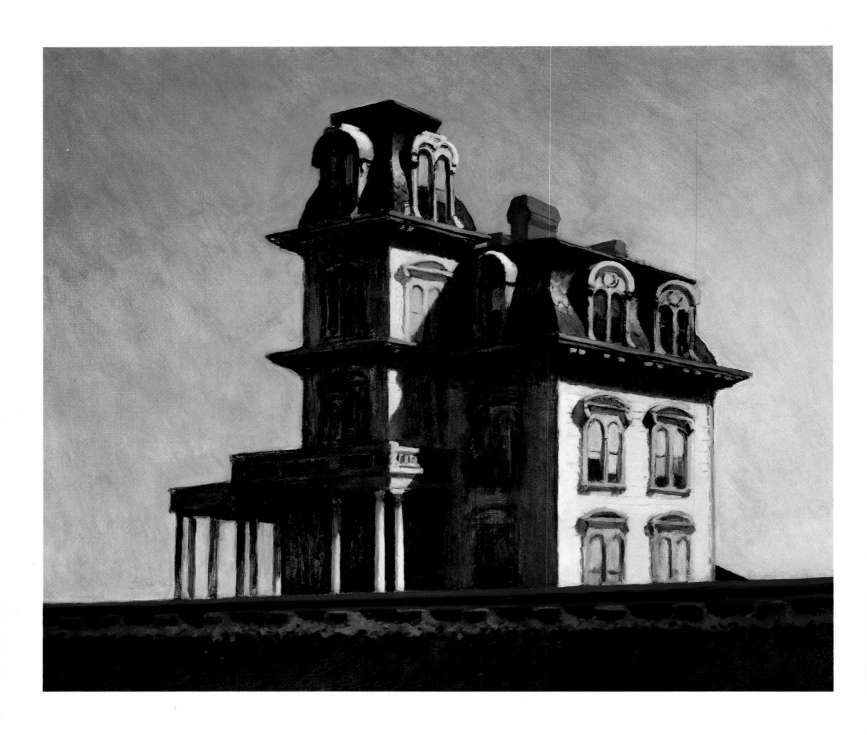

**House by Railroad**

*1925, oil on canvas;*
*24 x 29 in. (61 x 74 cm).*
*The Museum of Modern Art, New York.*
The growth of cities and railroads during Hopper's lifetime hastened the decline and desertion of many of America's small towns. In this work Hopper portrays the last vestige of a bygone era through his representation of a Victorian house beside a railroad track.

Unfortunately, Hopper has rarely been credited when his images have been appropriated for commercial purposes. Nonetheless, the wide use of Hopper's art commercially has, in some ways, allowed for the complete immersion of his art into today's mainstream culture. Consequently, one does not need to know who Edward Hopper was to be familiar with his art.

Despite the pop-culture appeal of his images, Hopper himself had very little interest in adopting the latest style or following the latest trend. He was a man of routine who preferred the simple things in life. His physical description matched his persona. In 1964, John Canaday, the art critic for the *New York Times*, described Hopper as follows: "A rangy, big-boned man whose appearance suggests that he might have been a member of his college crew around the year 1900."

Despite his success, Hopper's lifestyle changed very little throughout his adult life. He always maintained his primary residence at 3 Washington Square North in New York's Greenwich Village. From the 1930s onward, Hopper and his wife Jo divided the year between Washington Square and their second home in South Truro, Massachusetts. Moreover, the Hoppers always shopped in thrift stores and continued to purchase their clothes at Woolworth's and Sears.

Hopper displayed a similar lack of panache in his interaction with the art world. He was quite shy and incapable of mixing with the "right" dealers and critics. Nonetheless, during his own lifetime, Hopper witnessed two major retrospective exhibitions of his art and was the subject of a *Time* magazine cover story. Accordingly, one must wonder what accounts for Hopper's success as an artist during the first half of the twentieth century, let alone the wide appeal of his images to contemporary viewers.

Although Hopper may have had a rather staid lifestyle, artistically he followed his own instincts and inner visions, combining elements of the Ashcan and Impressionist schools to paint his own unique perspective of America. Hopper's art charts the growth of the cities and technological advances that occurred both in America's cities and its countryside from the 1920s through the 1960s. Hopper, however, chose to picture these changes by painting what was considered, during the early twentieth century, rather unusual subject matter, such as gas stations, hotel lobbies, night scenes, train tracks, lighthouses, offices, and train cars. Moreover, he liked his paintings to explore the psychological effects these subjects had on the people within his works. While Hopper's paintings of people are not narrative per se, his works do require interpretation. They often seem to catch the moment just after something has occurred among the people in the painting; for example, the elderly couple in *Hotel Lobby* (1943) seems to have just ceased bickering.

More than any other painter of the period, Hopper was able to capture the look and feel of American life. In an article for *The Arts Magazine* in 1927, Lloyd Goodrich, Hopper's ardent supporter and biographer, wrote, "It is hard to think of another painter who is getting more of the quality of America in his canvases than Edward Hopper." This ability clearly accounts for much of Hopper's success, yet it does not account for it all.

The appeal of Hopper's images to contemporary viewers as well as their adoption by pop culture must also be attributed to the themes of Hopper's paintings. During his lifetime, Hopper witnessed the shift of the American populace from the country to the city and the modernization of American transportation—changes which theoretically should have facilitated the bringing of people together. Nonetheless, Hopper saw these changes as exacerbating the isolation and alienation of the individual and repeatedly used his art to communicate this idea. The popularity of Hopper's art with contemporary viewers may stem from the universality of this message. Ironically, Americans today are experiencing a communications explosion which should serve to draw the whole world closer together through such mechanisms as the global internet. Yet, for many individuals, this new technology has resulted in an increasingly isolated, dehumanized existence in which faxes and e-mail have replaced human interaction.

*Following page:*
**Manhattan Bridge Loop**
*detail; 1928; oil on canvas;*
*Addison Gallery of American Art, Phillips Academy, Andover, Massachusetts.*
The massive architecture and concrete pavement of the bridge seems to engulf the walking figure. Hopper meant to capture the vast horizontal expanse of this structure and in doing so he also conveyed the dehumanization of city life. The bleak nature of this theme is strengthened by the drab colors of the neighboring buildings, the tonal flatness of the blue-gray sky, and the waning late-afternoon sunlight.

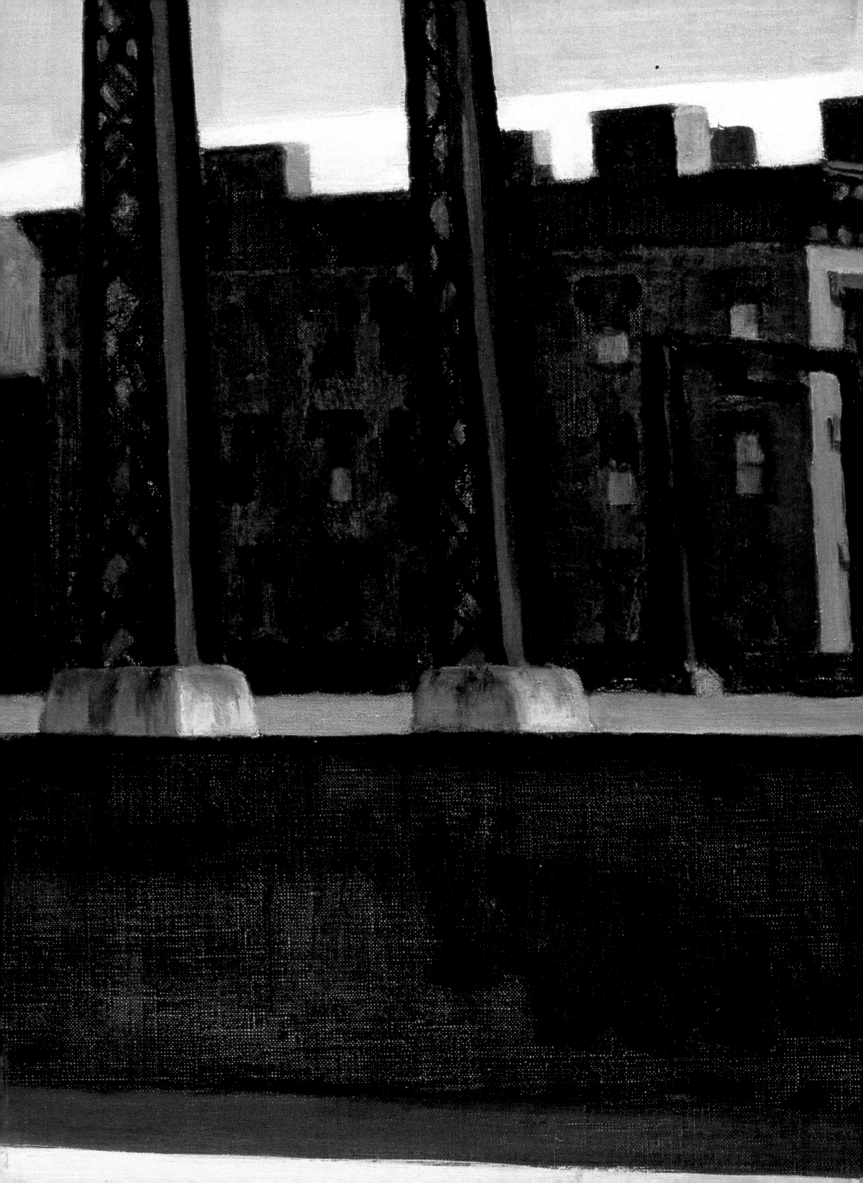

## Scholarship

Since the 1920s, many scholars and critics have written about the uniqueness of Hopper's art. Hopper's favorite theme of alienation has also been a frequent topic of analysis. As the totality of Hopper scholarship is far too extensive to discuss within a single chapter, this section focuses on the four scholars whose works have proven particularly helpful in researching this book.

Hopper's earliest biographer and an ardent supporter throughout Hopper's lifetime was Lloyd Goodrich. Though Goodrich wrote numerous books and articles on Hopper, his most comprehensive is *Edward Hopper*, published in 1971. Goodrich's book was the first truly informative biography on Hopper and laid the groundwork for others to follow.

One of the more intriguing articles on Hopper was written by Brian O'Doherty in December of 1964 for *Art in America*. O'Doherty had the opportunity to interview Edward Hopper in his New York studio, and his article is filled with Hopper's own anecdotes and statements. Through his descriptions and skillful questioning, O'Doherty was able to provide his readers with a glimpse into the inner sanctum of Hopper's world.

However, much of the research for this book has been obtained through the hard work and insightful analyses of Gail Levin, the foremost scholar on Hopper today and author of his catalogue raisonné, published in 1995. Levin spent many years as the curator of the Hopper Collection at the Whitney Museum of American Art, where she had the opportunity to delve into the Hopper archives. Building on the work of Lloyd Goodrich, Levin is the first art historian to interpret Hopper's art in terms of his relationship to French art, especially Degas, and the theater. Her thematic analyses and interpretations of specific works have been immensely valuable in the compilation of this book. While she has written numerous books and articles on Hopper, this text

has drawn most heavily from *Edward Hopper: The Art and the Artist*.

Robert Hobbs' *Edward Hopper* also provides perceptive analyses of Hopper's paintings. Hobbs' book contains interesting observations concerning the motivations behind some of Hopper's most famous works within the context of the cultural history of the period.

Finally, an excellent repository of Hopper's actual works and primary-source material is the

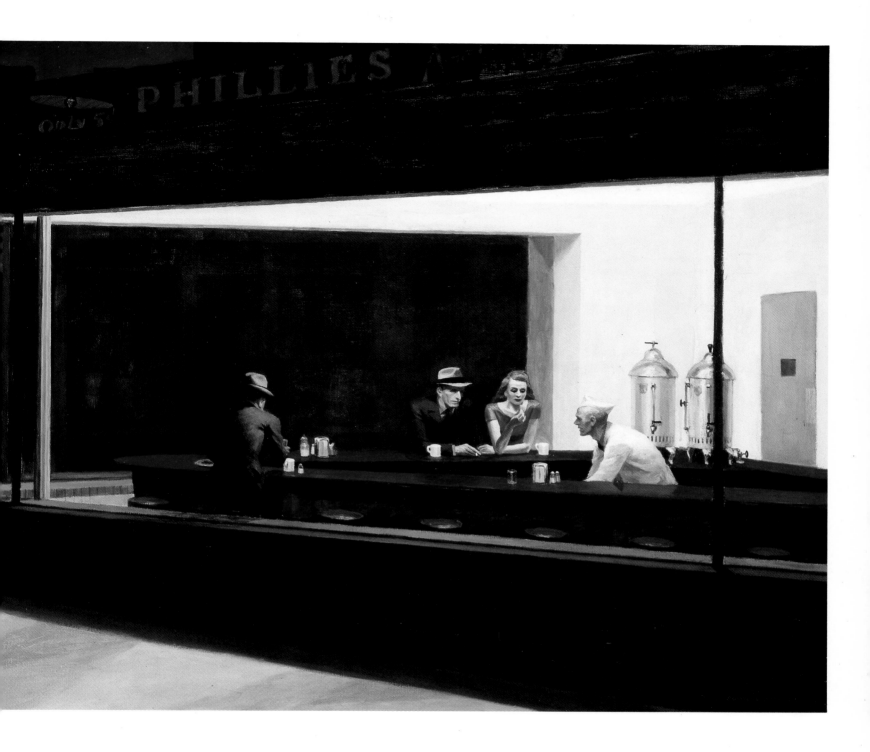

Whitney Museum of American Art. After her death in 1968 Hopper's wife, Josephine, bequeathed her husband's entire artistic estate to the museum. As a result, it houses today one of the most comprehensive collections of Hopper's art. Additionally, the Museum owns an enormous bulk of archival materials on the artist such as his ledger books and private correspondence. Furthermore, the Whitney has been a forerunner in promoting Hopper scholarship ever since it

**Nighthawks**
*1942, oil on canvas; 33 1/4 x 60 1/8 in. (84 x 153 cm).*
*The Art Institute of Chicago.*
One of Hopper's most famous works, *Nighthawks*, is a view of city life late at night. The locale is a diner in Greenwich Village which Hopper knew well. Fluorescent lighting was relatively new in the 1940s and Hopper makes use of its brightness to emphasize the diner's interior, an oasis of comfort in the dark night of the city.

mounted his first one-man show in 1920. Over the years the Whitney has organized a number of similar exhibitions, including its most recent in 1995, "Edward Hopper and the American Imagination."

## Methodology

With the exception of the first chapter, which describes Hopper's early experiences and influences, the remaining chapters of this book are divided thematically. In an approach similar to Levin's in *Edward Hopper: The Art and Artist*, Hopper's art is discussed in terms of the central themes that dominate his mature style. Nonetheless, throughout the book, a loose chronological order is followed so that the reader

moves from the beginning to the end of Hopper's life in an orderly fashion.

Chapter I introduces the reader to Hopper's early development as an artist. His student years in both New York and Paris are discussed at length, including his early interest in impressionism and his involvement with the Ashcan School. Hopper's mature style is the focus of Chapter II. Beginning with his rise to fame in the early 1920s, this section focuses on the subjects Hopper liked to paint in both New York and the rural countryside of New England. Alienation, a theme commonly portrayed in Hopper's art, is fully introduced in this chapter.

Chapter III discusses Hopper's interest in travel. This chapter was inspired by Robert Hobbs, who discussed the effects of the automobile on the American landscape at length in his book. Hopper's interest in the subject of travel also extended to his depictions of gas stations, the interiors of train cars, highways, and hotel rooms and lobbies, as well as to the psychology of the traveler.

Hopper's late works and the reemergence of sunlight in them is the focus of Chapter IV, the final chapter in this book. In his later years Hopper tended to allow sunlight to dominate his canvases. The reason for his renewed interest in light and the spiritual significance it may have held for Hopper is a central question of this section. The chapter ends with an examination of Hopper's final works and farewell painting, *The Two Comedians* (1965).

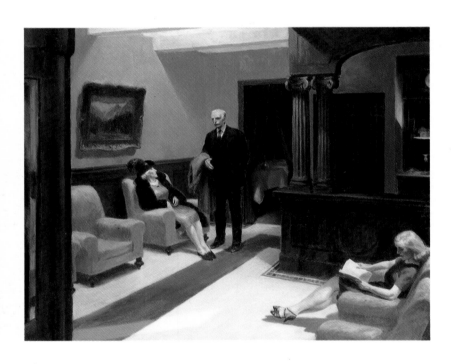

**Hotel Lobby**
*1943, oil on canvas; 32 1/2 x 40 3/4 in. (83 x 103 cm).*
*Indianapolis Museum of Art, William Ray Adams Memorial Collection.*
The frozen stillness and lack of interaction in Hopper's paintings were clearly intentional. In contrast to the finished painting, the preliminary drawings for *Hotel Lobby* show the elderly couple engaged in conversation and a young man seated in the place of the girl reading. Hopper used real-life observations, watching people in hotel lobbies for later use as models or as ideas to be composed and re-formatted in his studio.

**Early Sunday Morning**
*detail; 1930; oil on canvas;*
*Collection of Whitney Museum of American Art, New York.*
In "a literal translation of Seventh Avenue," Hopper presents the exterior of a barber shop, one of the small businesses that lined the avenue. Himself a small-town boy, Hopper favored the remnants of town life in New York, and his paintings are lasting impressions of the time preceding their ultimate demise.

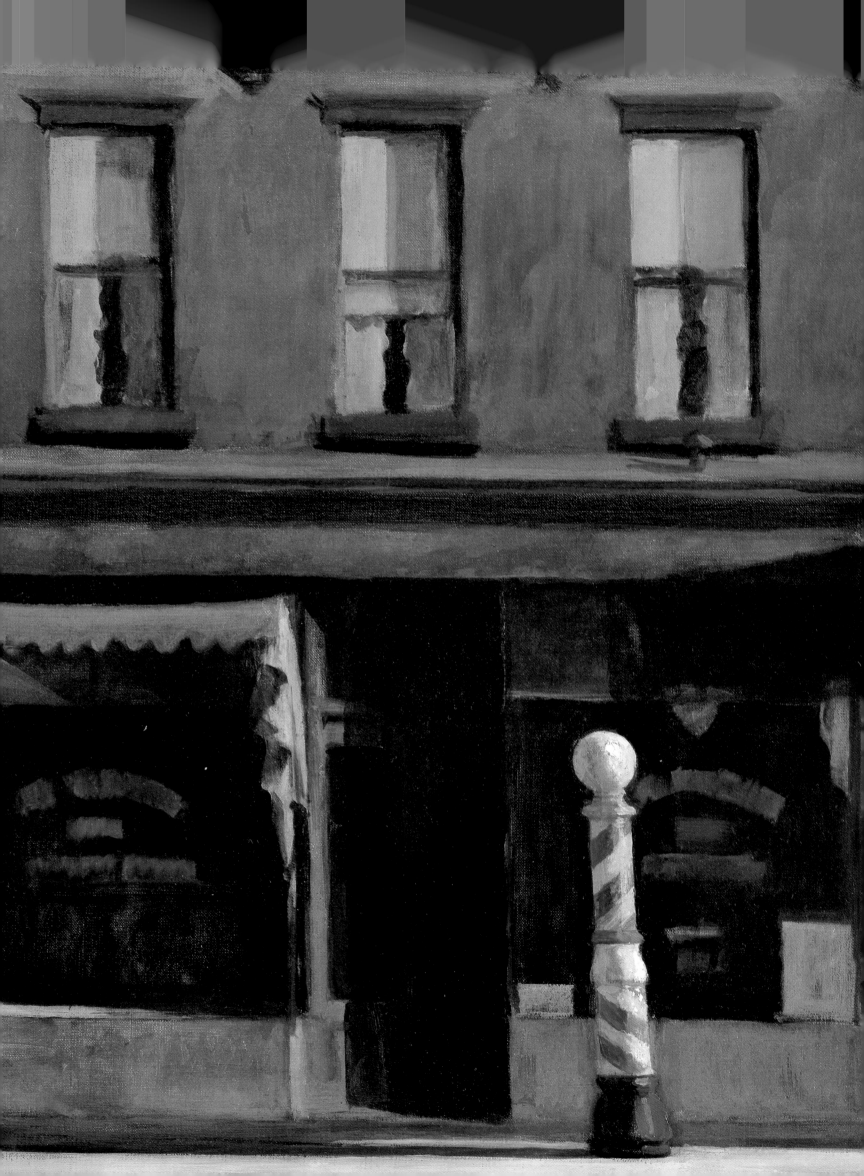

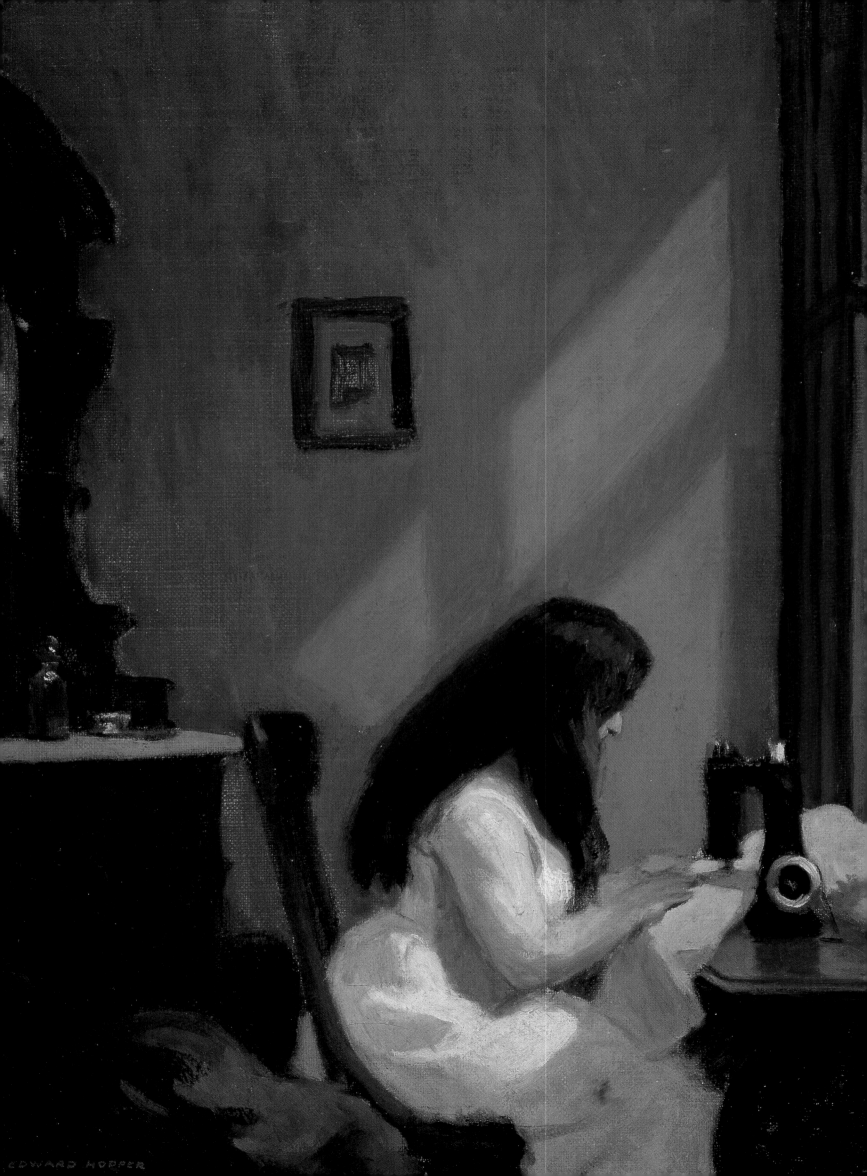

# EARLY DEVELOPMENT: NEW YORK AND PARIS

*A*ccording to Hopper, much of his artistic identity arose from his origins. Indeed, as the artist explained after achieving recognition, "in every artist's development, the germ of the later work is always found in the earlier. The nucleus around which the artist's intellect builds himself, the central ego, personality, or whatever it may be called, and this changes little from birth to death. What he once was, he always is, with slight modifications."

Edward Hopper was born in the small seafaring town of Nyack, New York on July 22, 1882. Hopper's parents, Garrett Henry Hopper and Elizabeth Griffiths Smith, were of English and Dutch descent. The family was middle class; Hopper's father was a local businessman who owned a dry-goods store in Nyack. Both Hopper and his sister Marion were exposed to the arts during childhood by their mother, who encouraged them to draw. Hopper was brought up attending a local private school and later Nyack High School.

Hopper's love of the sea, reflected in his later works, stemmed from his childhood. Hopper passed his childhood summer days at the shipyards of his hometown. When he was fifteen, his father gave him materials to build a catboat. Yet the boat never sailed very well and may have ended Hopper's dreams of pursuing a career as a naval architect.

## Student Days

After his high school graduation in 1899, Hopper wanted to pursue a career as a fine artist. His parents, however, had other aspirations for their son and, under their advisement, he enrolled at the Correspondence School of Illustrating in New York City.

## Girl at Sewing Machine

*c.1921, oil on canvas; 19 x 18 in. (48 x 46 cm).*
*Museo Thyssen-Bornemisza, Madrid 1995.*
The subject of this painting, a woman sewing by an open window, is a motif common
to the Ashcan School. Here Hopper transforms sewing, a subject often used by artists to
connote domestic harmony, into a study of light and the contemplation of the woman's
lone activity. Hopper later explored this same theme in his etching *East Side Interior* (1922).

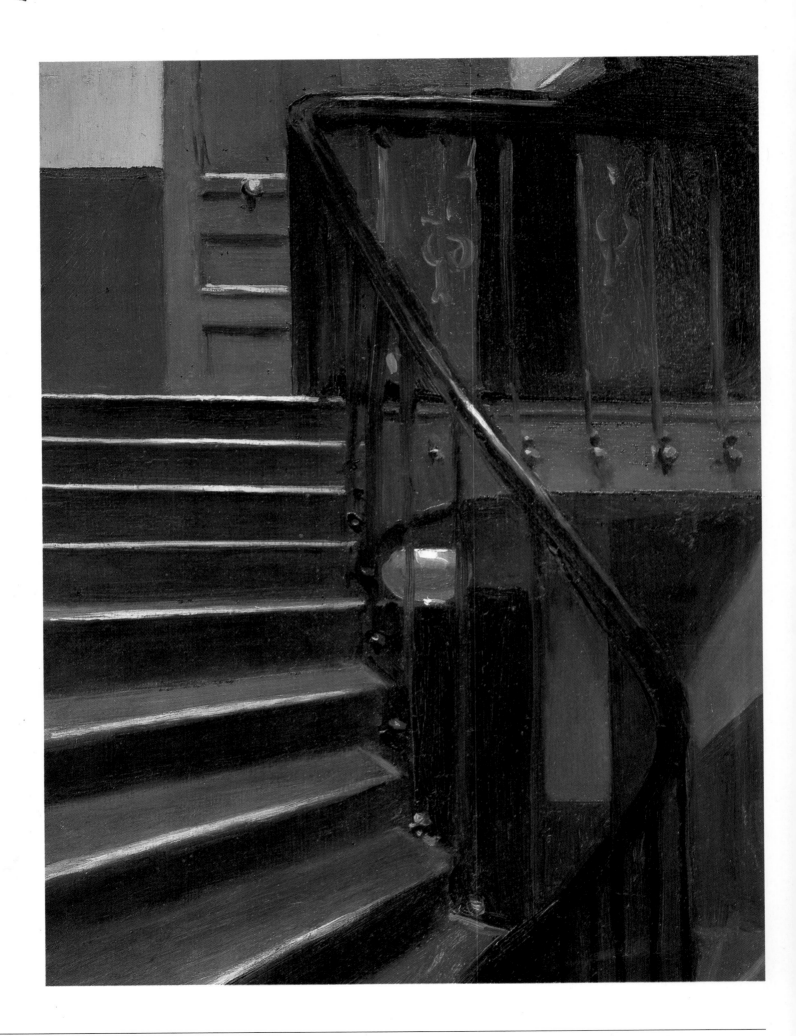

Disappointed with illustration school, Hopper transferred the following year to the New York School of Art, commonly known as the Chase School. For the next six years he studied there principally under William Merrit Chase, Kenneth Hayes Miller, and Robert Henri.

Chase himself painted in an impressionist style. The New York art scene during this period, however, was changing rapidly. In the early decades of the century, a radical group of American artists departed from the soft, genteel qualities of impressionism. This group of artists was commonly known as the Ashcan School. Although they retained much of the impressionist style, they sought to paint the harsher, more urban qualities of contemporary life. Their subject was the city, and they did not hesitate to portray its seedy side. Indeed, the name Ashcan School was coined as a derogatory comment on the bleak nature of the group's subject matter.

Hopper's teacher Robert Henri was one of the major proponents of this style. Moreover, Hopper's student works reveal that Henri, as opposed to Chase, was Hopper's primary influence at the Chase School. Though examples of Hopper's student works are limited, those that do exist evidence the dark palette and heavy brushstrokes favored by the Ashcan School. Additionally, Hopper's early exposure to Henri may have served as the catalyst for his future focus on depicting the harshness of city life.

## European Tour

From the eighteenth century through the early twentieth century, the goal of every American art student seemed to be to visit Europe. Recalling his European travels Hopper once said, "In my day you had to go to Paris. Now you can go to Hoboken; it's just as good."

Between 1906 and 1910 Hopper took several trips to Europe, which included extended stays in Paris. He earned the money for these journeys through illustration, a profession he abhorred but which would support him through his years as a struggling artist.

During his first trip to Paris in 1906, Hopper's parents arranged for him to stay with a French family on the Rive Gauche. Hopper recorded his stay with this family in his *Stairway at 48 Rue de Lille, Paris*. In this charming oil, he depicted the stairway of his hosts' Parisian apartment building.

Upon his arrival, Hopper was immediately captivated by Paris. He enjoyed strolling along the Seine, stopping at cafés, visiting the museums, and absorbing the artistic scenes. In an interview with Brian O'Doherty, Hopper reminisced,

> I could just go a few steps and I'd see the Louvre across the river. From the corners of the Rues du Bac and Lille you could see Sacré Coeur. It hung like a great vision in the air above the city. Who did I meet? Nobody. I'd heard of Gertrude Stein but I don't remember having heard of Picasso at all. I used to go to the cafés at night and sit and watch. I went to the theater a little.

Patrick Henry Bruce, a former classmate of Hopper's from the New York School of Art living in Paris, introduced Hopper to the works of the French impressionists, particularly Sisley, Renoir, and Pissarro. He also saw the works of Manet and Goya at the Louvre. Hopper was

### Summer Interior
*1909, oil on Canvas; 24 x 29 in. (61 x 74 cm).*
*Collection of Whitney Museum of American Art, New York.*
A young woman seated on the floor in a sunlit interior is an element common in many of Hopper's works. Hopper repeatedly used a female figure seated by a window to convey a range of feelings including loneliness, alienation, and sadness. The style of this early work has its precedents in the Ashcan School.

## Stairway at 48 Rue de Lille, Paris.
*1906, oil on wood; 13 x 9 1/4 in. (33 x 23 cm).*
*Collection of Whitney Museum of American Art, New York.*
This is a view of the entrance to the house in which Hopper stayed during his first trip to Paris in 1906. His early interest in architectural forms is apparent and the unusual placement of these elements will continue to be a characteristic of his style.

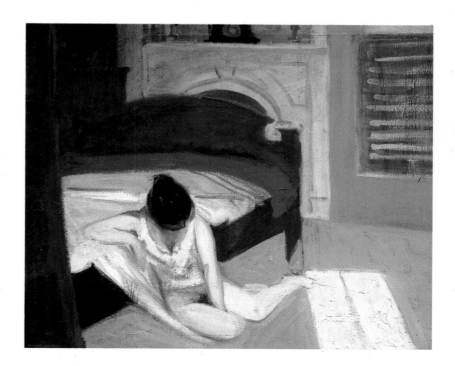

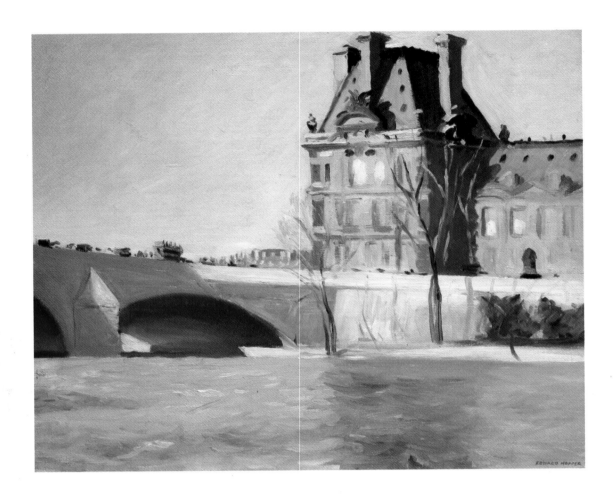

**Le Pont Royal**
*1909, oil on canvas;*
*23 1/4 x 28 1/2 in. (59 x 72 cm).*
*Collection of Whitney Museum*
*of American Art, New York.*
Painted during his second trip
to France in 1909, this painting
reflects Hopper's interest in the
works of the French Impressionists,
in particular Sisley, Renior, and
Pissaro. The work, painted in an
impressionist manner, displays
one of the artist's early concerns:
he once stated that all he really
wanted to do was to paint sunlight.

**Le Bistro**
**or the Wine Shop**
*1909, oil on canvas;*
*23 3/8 x 28 1/2 in. (59 x 72 cm).*
*Collection of Whitney Museum*
*of American Art, New York.*
Here, Hopper portrays one of
the Bistros along the banks of the
river Seine. His fascination with
the Parisian lifestyle is evident
by the many street scenes he
captured during his visits to Paris.

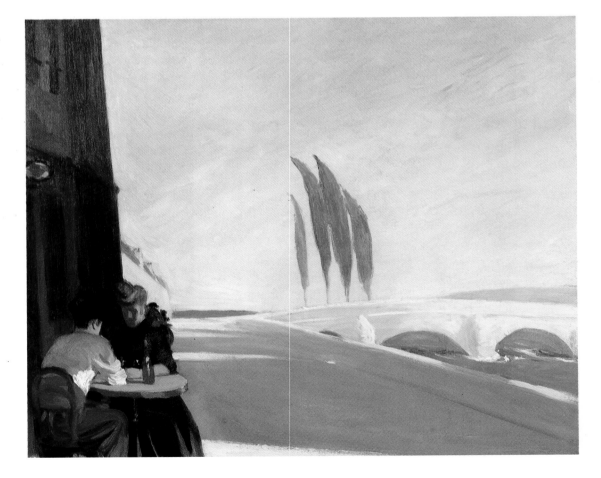

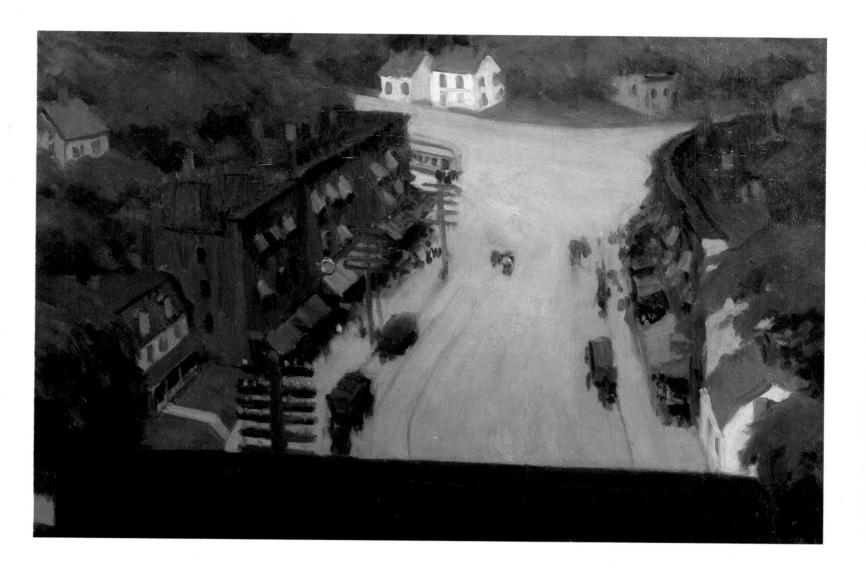

impressed and intrigued by the works of all these artists and, as a result, began experimenting with an impressionist style as well as pointillism. Hopper's paintings from this period, such as *Le Pont Royal* (1909) and *Le Bistro or the Wine Shop* (1909) closely resemble the subjects and working methods of the Impressionists, especially their emphasis on sunlight.

## Struggling Years

After 1910 Hopper never returned to Europe. Except for occasional excursions out west, he spent the remainder of his life in New York and New England. The years following his return home were marked by difficulty and struggle. Hopper was forced to support himself as a commercial illustrator, a pursuit he hated.

By this time, Hopper was already committed to being a fine artist, and his work as an illustrator, though financially necessary, distracted him from what he now considered his true calling. As he once stated, "Illustrating was a depressing experience. And I didn't get very good prices because I didn't often do what they wanted." Accordingly, Hopper refused to work in advertising more than three days a week or at all during summers, thus leaving some opportunity to pursue his own art.

Despite the demands of his commercial activities, Hopper found time to enter his works in group exhibitions almost immediately upon his return. He participated in the 1910 exhibition of independent artists arranged by his teacher Robert Henri and John Sloan. Although Hopper's style at this point in his artistic development was more akin to impressionism, his affiliation with this show identified him as one of the emerging

**American Village**

*1912, oil on canvas;*
*26 x 38 in. (66 x 96 cm).*
*Collection of Whitney Museum*
*of American Art, New York.*
Hopper painted the main street of this quintessential American town from an unusual vantage point—above. Having grown up in Nyack, New York Hopper was quite familiar with small-town life. Additionally, he spent the summer of 1912, the year this work was executed, in Gloucester, Massachusetts, and it may be a record of his stay there.

artists of the Ashcan School. In 1913, Hopper entered *Sailing* into the International Exhibition of Modern Art, commonly known as the Armory Show. This work sold for $250. Unfortunately, it would be his first and last sale of a painting, as opposed to illustrations and prints, for over a decade. That same year Hopper moved his studio to 3 Washington Square North. This address would serve as his studio and home for the remainder of his life.

Despite his lack of recognition, Hopper experienced much growth as an artist during the decade following his first sale. He experimented with a melange of artistic styles, and it is not surprising to see both Impressionist and Ashcan techniques in his works of this period.

Nonetheless, the impact on Hopper's art of his trips to Europe extended well into the 1910s. Hopper once said, "It took me ten years to get over Europe." As of 1915, Hopper still felt that his French works were superior to his American ones and preferred to enter

them into exhibitions. The culmination of Hopper's preference for French subject matter is best exemplified by his *Soir Bleu*, a work he submitted to the McDowell Club group show of 1915. Gail Levin has suggested that Hopper was working within the French tradition of the *fête galante*, and that his clown is a modern version of Watteau's *Gilles* (c. 1721). Additionally, Levin has commented that the standing woman in the work is a prostitute approaching prospective clients—an idea Hopper may have borrowed from his attendance at the Carnival of Mi-Carême in 1907. Despite the ambitious nature of the work, critics reviewed it negatively. Instead, they admired Hopper's other submission, *New York Street Corner* (1913).

In response to the negative criticism of *Soir Bleu*, Hopper never again entered the work in an exhibition. Furthermore, his subsequent submissions to the McDowell Club group shows, such as *American Village*, dealt primarily with American subject matter.

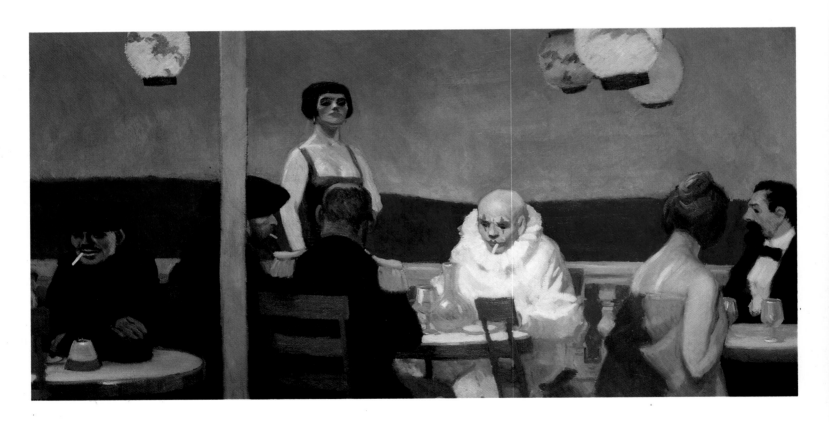

**Soir Bleu**

*1914, oil on canvas; 36 x 72 in. (91 x 183 cm).*
*Collection of Whitney Museum of American Art, New York.*
In the tradition of Watteau's *fête galantes*, this painting reveals
Hopper's interest in French subject matter shortly after his travels
abroad. When the work was exhibited at the MacDowell Club in 1915
critics unfavorably viewed it as an "ambitious fantasy." It was Hopper's
more American-style works that would later attract critical attention.

**Le Pont Royal**
*detail; 1909; oil on canvas;*
*Collection of Whitney Museum of American Art, New York.*
In the manner of the French Impressionists, Hopper
painted his Parisian subject of *Le Pont Royal* with strong
brushstrokes. The artist conveys the immediacy of
the moment through his rendering of light and water.

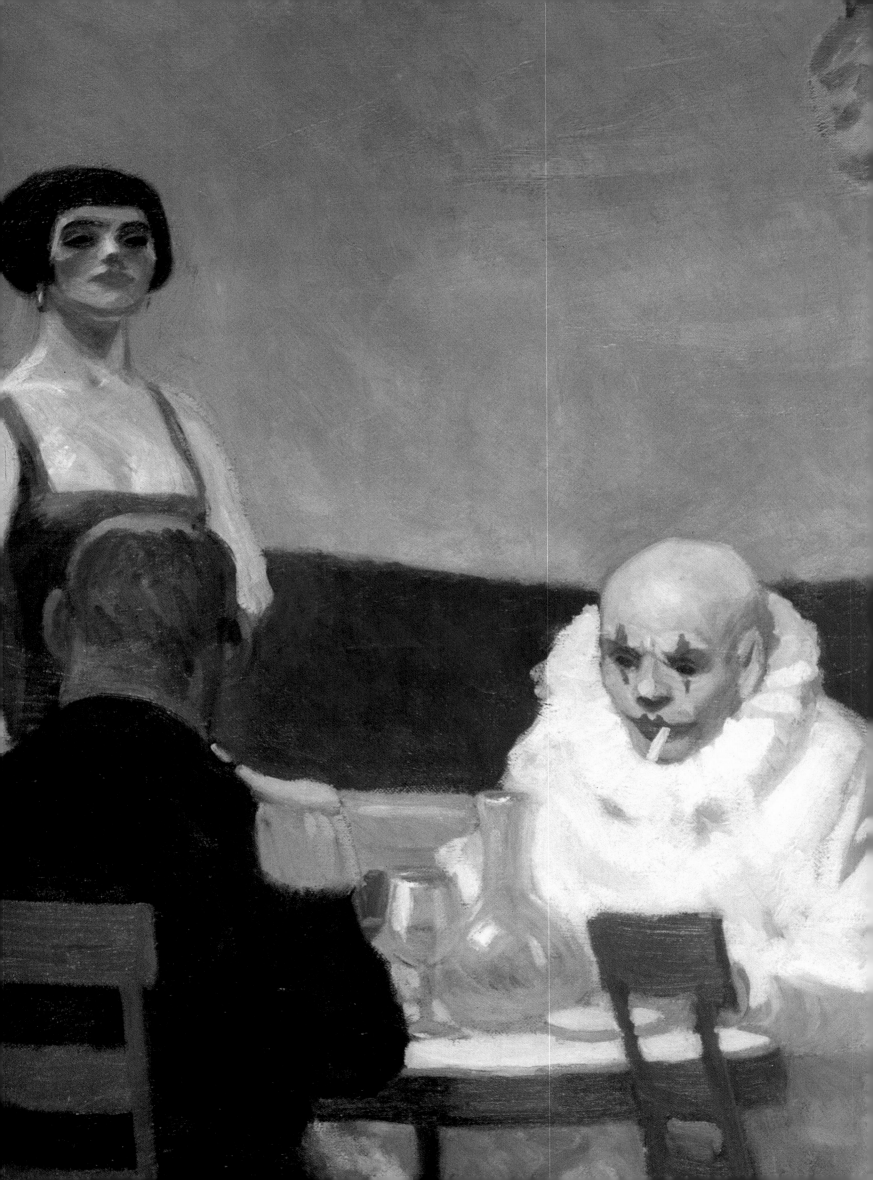

## Summers in Maine

During the 1910s Hopper's commercial work flourished. He illustrated regularly for such magazines as *The Farmer's Wife* and *Country Gentleman*. The money he earned as an illustrator enabled him to spend summers in Maine. In 1916, Hopper joined fellow artists Robert Henri, Rockwell Kent, and George Bellows in Monhegan Island, Maine. He was captivated by the rocky coastline of Maine and produced a number of works during the many summers he spent there. Hopper painted outdoors, and his works such as *Blackhead Monhegan* (1916-19) and *Rocky Cliffs by Sea* (1916-19) reveal the rugged, tempestuous qualities of nature.

Moreover, these works contain a temporal quality which Hopper created through his use of brushstrokes and thick impasto. It is interesting to note that virtually all of Hopper's Maine paintings border on abstraction and are yet another example of the artist's experimental nature during this period.

## Etching

Although his paintings did not sell during the 1910s, Hopper did begin to experience success as a fine artist during this period through his etchings. In 1915, he was introduced to this medium by his friend Martin Lewis. His prints subsequently sold well, and he began to exhibit them regularly. Hopper's poster *Smash the Hun* (1918), for example, won first prize from the United States Shipping Board poster competition. He also made a number of movie posters during the late teens, as well as a poster for the American Red Cross.

The etchings of the early twenties are perhaps the closest in subject matter to Hopper's mature works, for in these works he concentrated on city life. His etching *Evening Wind* is a precursor to his later works of solitary women by windows. Robert Hobbs has suggested that it is a modern-day Danaë. Hobbs has further suggested that Hopper's etchings of this era may have been inspired by John Sloan's New York City Life etching series.

In *Night Shadows* (1921), Hopper adopted an unusual vantage point, an element characteristic of his mature style, for his etching of a lone figure walking down a deserted street at night. His depiction of the night, with its artificial light, lends an air of mystery to the piece. As in all of Hopper's later works the narrative is left up to the viewer to decipher. Furthermore, alienation, a common theme in Hopper's later paintings, is partially introduced into this early work through the isolation of the walking figure.

By the 1920s Hopper was gravitating towards his mature style. Through his etchings of city life, he was able to forge his own artistic style, apart from those of the Impressionist and Ashcan schools. That is not to say that he did not retain certain aspects of these styles; throughout his lifetime he would always be concerned with depicting sunlight and city life. Hopper's mature style, however, relied on something much more important than the influence of artistic schools. As Hopper himself explained: "The only real influence I've ever had was myself."

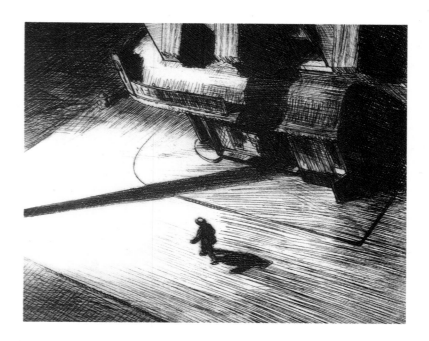

### Soir Bleu

*detail; 1914; oil on canvas;*
*Collection of Whitney Museum of American Art, New York.*
Of the many characters in this painting, the clown smoking a cigarette is perhaps Hopper's most poignant. Furthermore, the clown's presence lends a theatrical note to the work. Though none of the other seated figures are as vividly portrayed, the sad, downcast aspect of this strikingly-costumed man contrasts strongly to the haughty assurance of the woman standing on the left.

### Night Shadows

*1921, etching; 7 x 8 3/8 in. (18 x 21).*
*Collection of Whitney Museum of American Art, New York.*
In 1915 Hopper was introduced to the etching medium by his friend Martin Lewis. The resulting etchings were the first of Hopper's works to sell and receive critical acclaim. Here he employs an unusual bird's-eye-view of the subject, a lone figure walking on a deserted sidewalk at night. Hopper's art seems to have been the stimulus for the 1940s cinematic style *film noir*.

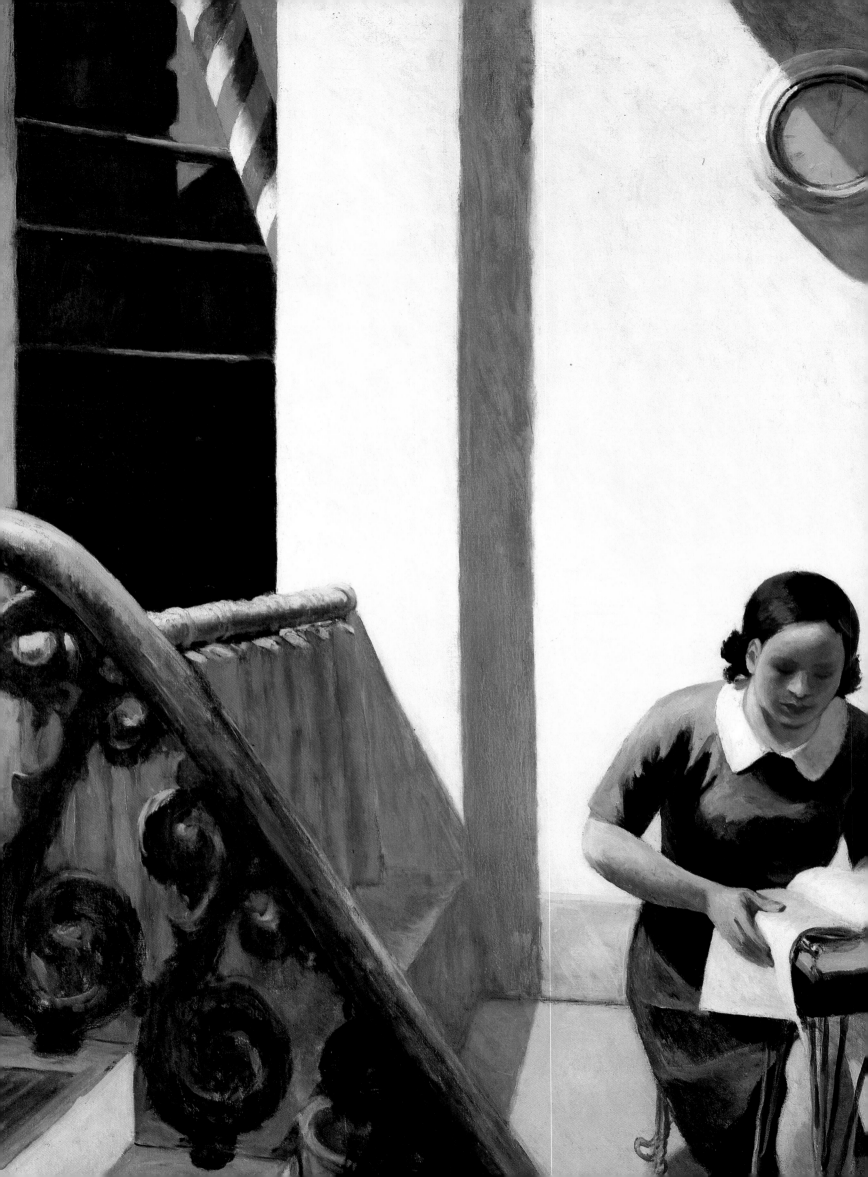

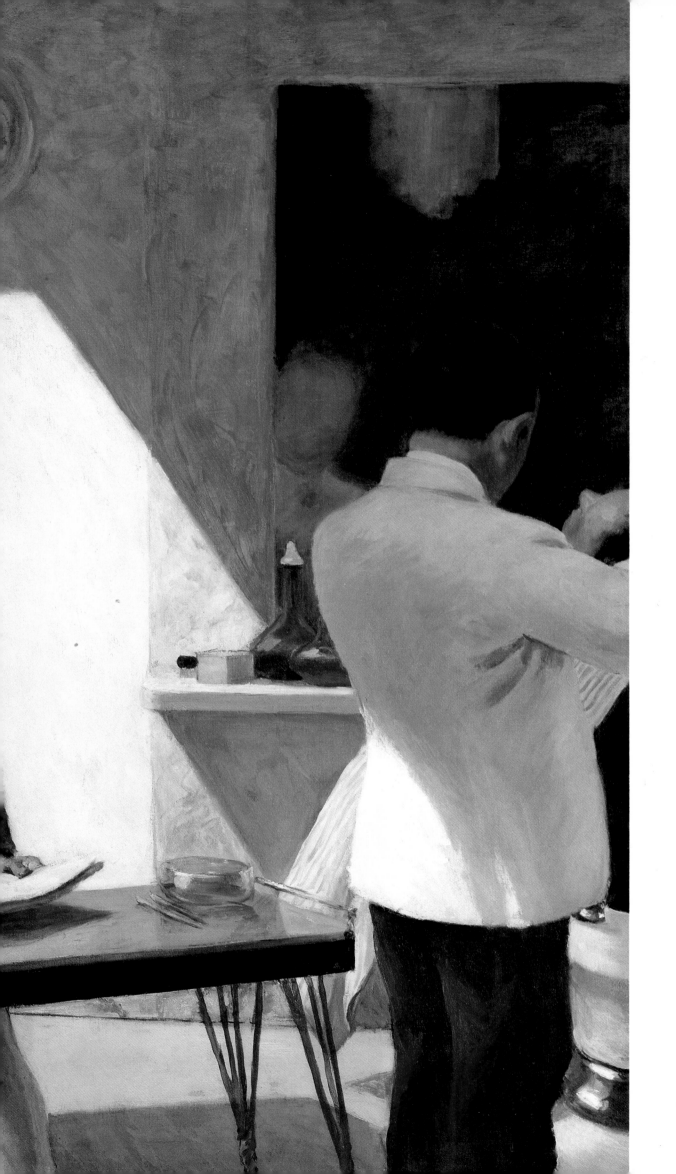

**The Barber Shop**
*1931; oil on canvas;*
*60 x 78 in. (152 x 198 cm).*
*Collection of Neuberger*
*Museum, Purchase College,*
*State University of New York,*
*gift of Roy R. Neuberger.*
The interior of this barber
shop could well be one
of the storefronts in *Early
Sunday Morning*. Hopper
conveys the quiet solitude
of the place, a theme close
to his heart, through his
depiction of the manicurist.
Free from distraction, she
reads a magazine while
waiting for a customer.

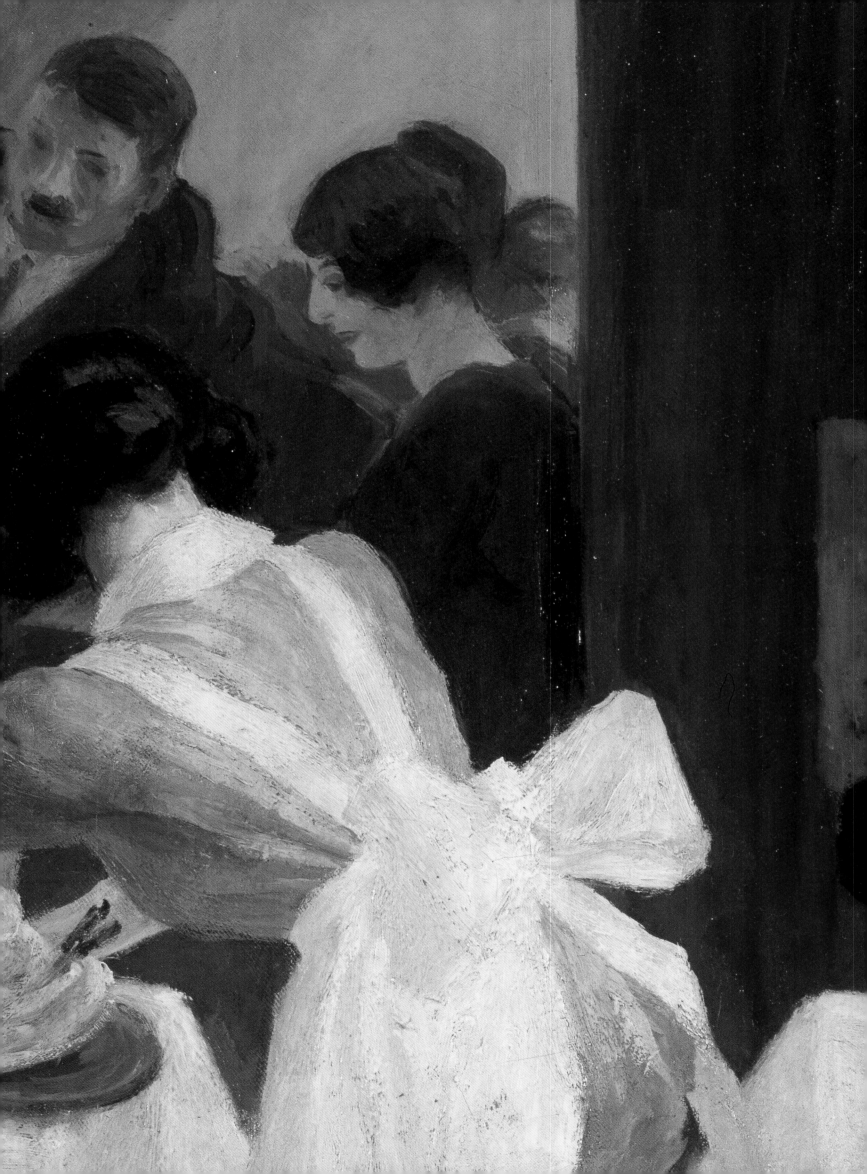

# MATURITY: LIFE IN THE CITY AND COUNTRY

During the 1920s and 1930s, Hopper's art increasingly gained recognition. By 1933, he was considered a leading American artist of the period—a position confirmed by his retrospective exhibition at the Museum of Modern Art in that same year.

Hopper's personal life flourished during this period as well. In 1924 he married Josephine Verstille Nivison or, as Hopper fondly called her, Jo. In Jo, he found a soulmate, and for the next forty-three years the Hoppers were inseparable. Moreover, Jo's contribution to the artist's success was profound. She was a formidable woman who promoted her husband's work, managed most of his affairs and also served, possibly due to her own jealousy, as Hopper's only female model after their marriage.

## Edward and Jo

Hopper met Jo during their student days at the New York School of Art where both were students of Robert Henri. Henri's portrait of Jo, entitled *The Art Student* (1906), captures the youthfulness that Hopper must have seen upon his first encounter with her. Nonetheless, Hopper and Jo initially viewed each other only as friends. The romance between the two did not begin until years later.

In December of 1922 both Hopper and Jo were included in the same group show, by chance, at the Belmaison Gallery at John Wanamaker's in New York. This show may have helped to spark their romance, as the two spent the following summer together in

**Jo Painting**
*1936, oil on canvas; 18 x 16 in. (46 x 41 cm).*
*Collection of Whitney Museum of American Art, New York.*
Primarily a watercolorist, Jo's art was overshadowed by Hopper's success, and after they married she became his manager and defense against the world. Jo insisted that she be the model for all of Hopper's female figures, and from 1924 on she is the key player in all of his paintings. Though he painted her in many moods and guises, this is a rare portrait of Jo herself.

**New York Restaurant**
*detail; 1922; oil on canvas;*
*Hackley Picture Fund, Muskegon Museum of Art, Michigan.*
The sharp angle of the waitress's body as she leans forward to clear a table, which is largely cropped from our view, successfully captures the bustling activity of a crowded city restaurant at the lunch hour.

## Mansard Roof

*1923, watercolor on paper;*
*13 3/4 x 19 in. (35 x 48 cm).*
*The Brooklyn Museum, New York.*
In the summer of 1923 Hopper
was in Gloucester, Massachusetts.
His honest portrayal of this seafaring
town can be seen in the many water-
colors he executed during his stay
there. Among them, *Mansard Roof*
was the first of Hopper's works to be
purchased by a museum collection.

Gloucester, Massachusetts. In Gloucester, Jo encouraged Hopper to experiment with watercolors, and he quickly adopted the medium to capture the architecture and land-scapes of the New England coast. With Jo's aid, these watercolors became Hopper's first success after the acceptance of his etchings.

In 1923 the Brooklyn Museum invited Jo to submit six of her watercolors to a group show of European and American artists. Upon Jo's recommendation, Hopper was also invited to participate. He chose to exhibit his most recent works: six of the watercolors painted in Gloucester during the summer of 1923. The reaction to these pictures was stupendous. While Jo's work went unnoticed, critics such as Helen Appleton Read and Royal Cortissoz described Hopper's watercolors as suggestive of Winslow Homer and quite "exhilarating."

Later that year, the Brooklyn Museum purchased Hopper's *Mansard Roof* (1923), one of the watercolors from the group show. It was Hopper's first sale, apart from his etchings, in over ten years and marked the beginning of his success as a painter.

## Recognition

As a result of his success at the Brooklyn Museum, Hopper was offered a one-man exhibition at the Frank K. M. Rehn Gallery in New York. The show opened in the fall of 1924 and presented eleven of his watercolors. Not surprisingly, all of them were sold, as well as five additional pieces that did not appear in the show. The critic for the *New York Times* found the works to be "a striking group of watercolors."

The success of the Rehn Gallery exhibition marked the turning point in Hopper's career. After this he was able to support himself solely as an artist. Moreover, the financial freedom to devote himself entirely to his art came at a particularly fortuitous moment, because it was at this time that Hopper's interest in oil painting resurfaced and his mature style evolved.

## Mature Style

The style of works for which Hopper is best known today began to emerge in the mid-1920s. During this period, the artist not only developed a preference for certain subjects which would recur in his later paintings, but also adopted compositional elements that he would use throughout his life.

The paintings for which Hopper became famous are his scenes of American life during the early twentieth century. He liked to paint ordinary subjects, such as gas stations, lighthouses, trains, hotel lobbies, and desolate towns. Additionally, Hopper's paintings of city and country scenes documented the growing changes that occurred both before and after World War II.

The themes of Hopper's paintings, the isolation of the individual within the city and the desolation of the countryside, are conveyed through his use of specific compositional elements. Levin outlined some of these formulas as follows: "These include a simple frontal view parallel with the picture plane, a scene viewed at an angle from above, and a subject placed on an oblique diagonal axis cutting into the picture's depth."

Hopper's art draws from his advertising background. Similar to commercial illustrations, the primary focus of many of Hopper's paintings is his figures. He never ventured far from reality and, like an illustrator, depicted subjects which could be interpreted narratively. Yet the manner in which his canvases are divided is unique and creates the intriguing vantage points described by Levin. For example, in *New York Pavements* (1924), Hopper looks down onto the street, as though from a second-story window, and cuts off from view the lower part of the body of the strolling nanny and part of the baby carriage. As a result of such an unusual viewpoint and division of subject matter, what would otherwise be considered an ordinary scene becomes captivating. Colors also play an important role in creating the mood evoked by Hopper's paintings. Greens, blues, and yellows were among his favorite colors, and he used them lavishly throughout his career.

Hopper composed his paintings in his studio at Washington Square. While he did rely on sketches, it is important to recognize that his works, though realistic, were created from the artist's imagination. In the 1920s

**New York Pavements**
*1924, oil on canvas;*
*24 x 29 in. (61 x 74 cm).*
*Chrysler Museum of Art,*
*Virginia.*
Hopper uses an overhead view in his portrayal of a nanny pushing a baby carriage. The apparent influence of the French Impressionist Degas in this work is no mere coincidence. In 1924 Hopper's wife gave him a book on Degas, and the sudden appearance of unusual vantage points and cropped figures in his paintings can be at least partially attributed to this occurance.

and 1930s it took Hopper only a week to complete a painting. From 1940 onward, however, he produced no more than two to four oils per year.

Another interesting aspect of Hopper's mature style is the imaginative fantasies played out in his paintings. The ledger books of his works reveal that he and Jo nicknamed many of the characters in the paintings and created elaborate stories surrounding them. In *Intermission* (1963), he and Jo named the woman in the work Nora. Nora's character is described by the Hoppers as one who "is not the kind to slip feet out of long reasonably high heeled pumps." Hopper further theorized that "Nora is on the way to becoming an 'egghead.'" Hopper's ledger books also reveal that the relationship between himself and Jo was quite crucial to the formation of his style. Jo not only served as Hopper's muse but was also his collaborator in their game of storytelling.

Once developed, Hopper's mature style changed little over the years. While he painted in a realist style and continued to be interested in sunlight and the city—a continuation of the Impressionist and Ashcan traditions—his works remain unaffiliated with any one school. Indeed, when asked late in life what he was trying to accomplish, Hopper responded, "I'm after me." Accordingly, it is best to view Hopper's paintings in terms of the unique themes and subjects he chose to paint.

## City Views

Hopper's city scenes explore the alienation and loneliness of urban existence. During his lifetime, the artist witnessed the rapid growth and expansion of New York City. When he first arrived in New York in the early 1900s, the city still possessed some remnants of small-town life. By the 1930s, however, this small-town atmosphere was waning.

Hopper's interest in New York as a subject for his paintings seemed to be centered around the effects of the city's growth on both its architecture and population. Instead of focusing on the excitement of the city,

### Office at Night

*detail; 1940; oil on canvas;*
*Walker Art Center, Minneapolis.*

The voluptuous secretary invitingly glances out at the viewer. Her subordinate position in this office is cleverly emphasized by the placement and cropping of her desk and typewriter. Small to begin with, it is further diminished in our view by the fact that we see only a portion of it. Compared to the ample desk of the man's, it appears cramped and uncomfortable.

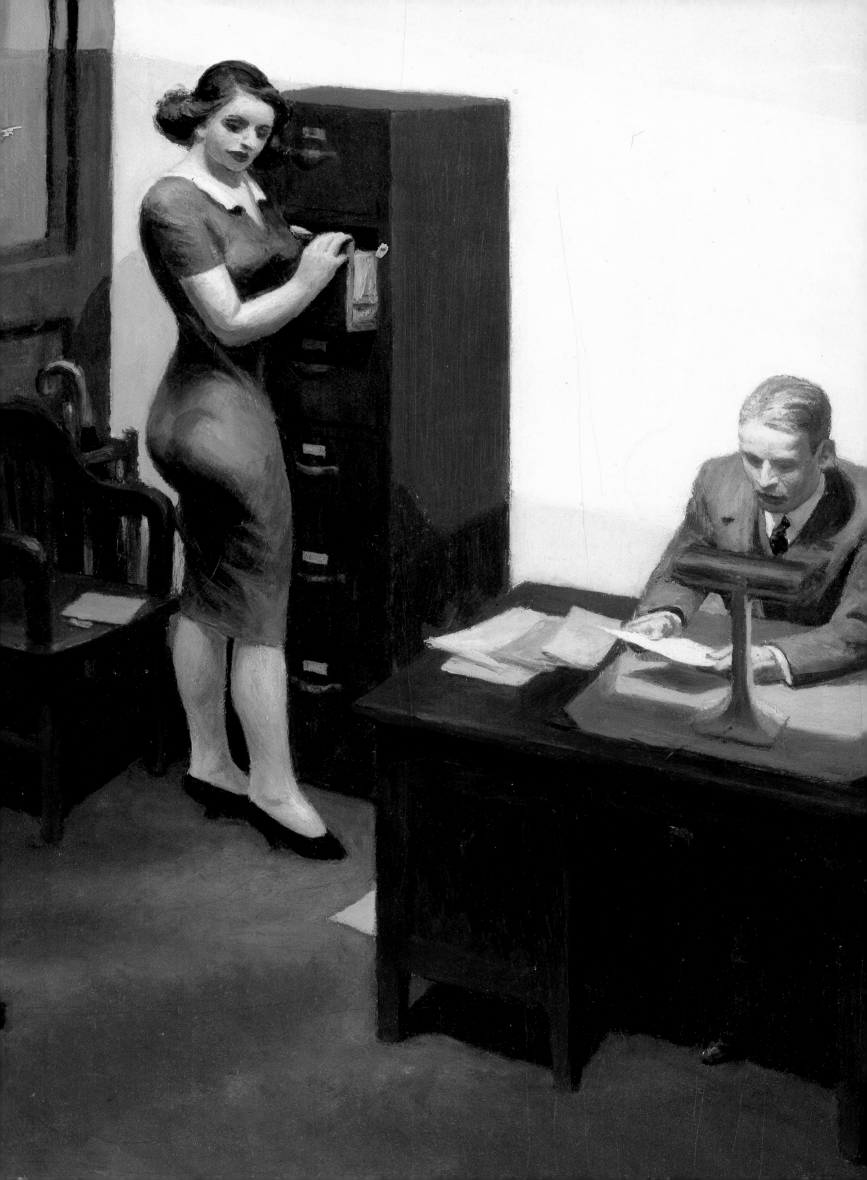

his paintings portray the cold, steely side of urban life. It is interesting that Hopper, who was born in a small town, frequently communicated these themes through depictions of subjects which reflected the last vestiges of town life in New York. *Drug Store* (1927), *Manhattan Bridge Loop* (1928), and *Early Sunday Morning* (1930) exemplify Hopper's perspective of the city during this period.

*Drug Store*, a nocturnal scene, depicts Silber's Pharmacy, a family-run business. The lighted shop appears out of the dark as a welcome sight to the stroller. Apparently Hopper found this small, old-fashioned store appealing and reassuring.

Hopper's preference for family-run businesses as subjects is again seen in his *Early Sunday Morning*. The artist once stated that the work "was almost a literal translation of Seventh Avenue." According to Hobbs, the barber pole and the curtains in the second-story windows indicate that the shops are small businesses, the types of service-oriented stores that were able to survive the depression.

**Drug Store**

*1927, oil on canvas; 29 x 40 in. (74 x 102 cm).*
*Museum of Fine Arts, Boston.*
Hopper's treatment of a commonplace subject, such as Silber's Pharmacy, becomes all the more interesting as a night scene. The pictorial effects of the lighted store and the objects in the window create an eerie romantic atmosphere. Hopper's night scenes recall the night cafés of Van Gogh.

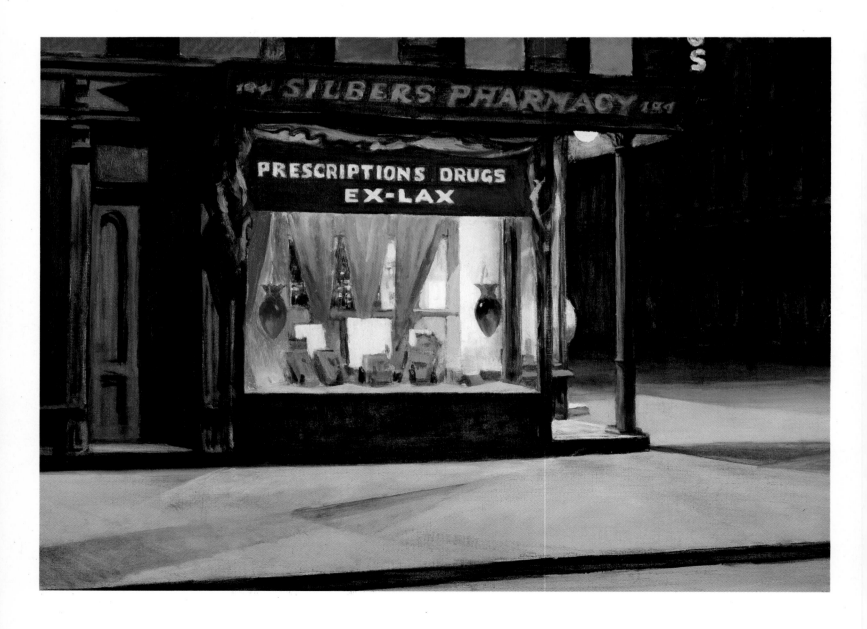

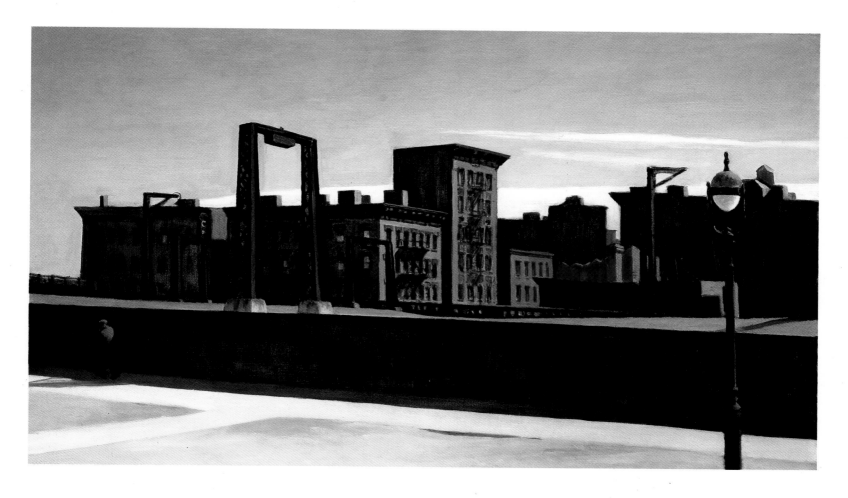

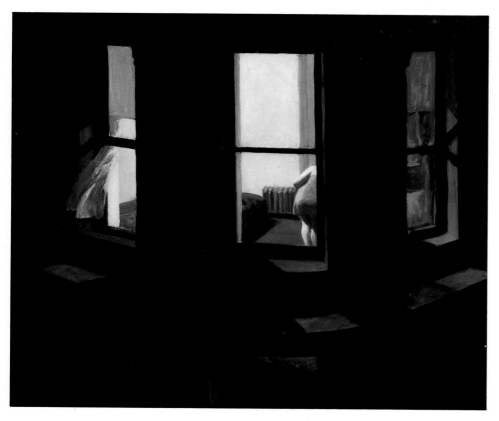

## Manhattan Bridge Loop

*1928, oil on canvas; 35 x 60 in. (89 x 152 cm).*
*Addison Gallery of American Art,*
*Phillips Academy, Andover, Massachusetts.*
This depiction of a lone figure walking on a
bridge in the early morning hours reflects the
care and thought Hopper took in deciding the
subjects and proportions of his paintings. For
*Manhattan Bridge Loop*, Hopper commented: "The
very long horizontal shape of this picture...is an
effort to give a sensation of great lateral extent."

## Night Windows

*1928, oil on canvas; 29 x 34 in. (74 x 86 cm).*
*The Museum of Modern Art, New York.*
Hopper often adopted a voyeurish view of women
in his paintings. In *Night Windows*, one sees from
the outside a private moment as a woman bends
forward in an ungainly fashion. Perhaps she is
undressing for the night. As the viewer joins the
artist as a cold, casual observer, a certain poignancy
is created by the woman's vulnerability and her
unawareness that she is watched by strangers.

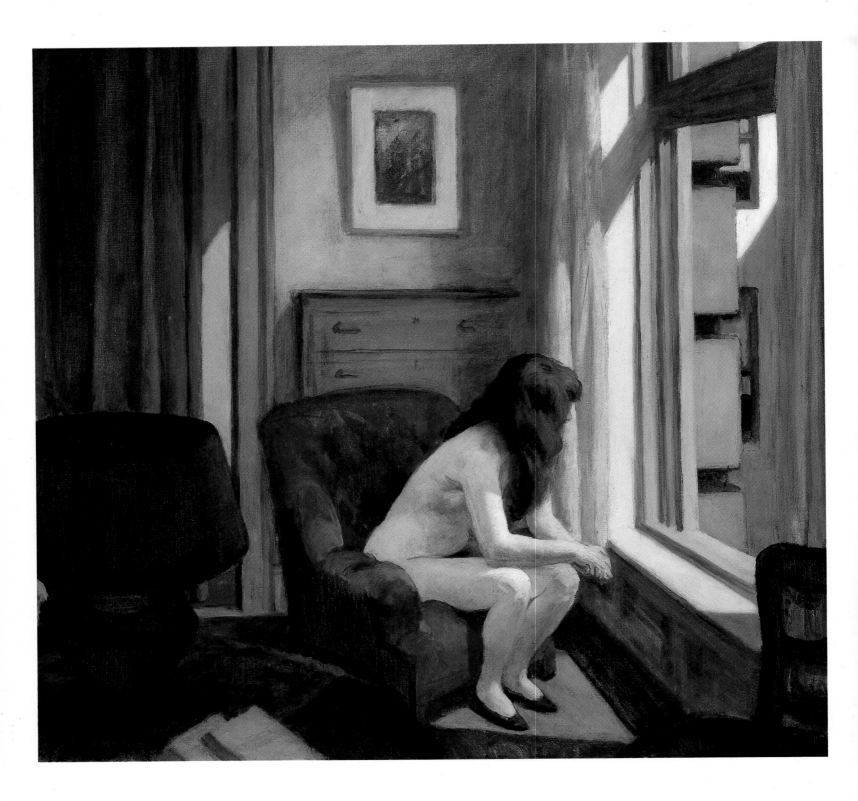

### Eleven A. M.

*1926, oil on canvas; 28 x 36 in. (71 x 91 cm). Hirshhorn Museum
and Sculpture Garden, Smithsonian Institution, Washington, D.C.*
Hopper was always interested in painting light at specific times of day.
In this view of a domestic interior the time is late morning. A woman,
whose back is turned from the viewer, looks out of the window. Unlike
most nude studies, the nakedness of the woman is not the central
element in this picture. Rather it is the play of sunlight as it penetrates
the interior of the room, highlighting its furnishings and objects.

The dwarfing of the individual within the city is best dis-
played in Hopper's *Manhattan Bridge Loop*. In this painting
he depicts a solitary pedestrian walking across a bridge. The
alienation and dehumanization of this individual is empha-
sized by the long, horizontal format and by the person's
insignificance in relation to his surroundings. In contrast to
Joseph Stella's *Brooklyn Bridge* series of the 1920's, which
illustrates a positive look at technology, Hopper's work
emphasizes the unheroic qualities of the urban landscape.

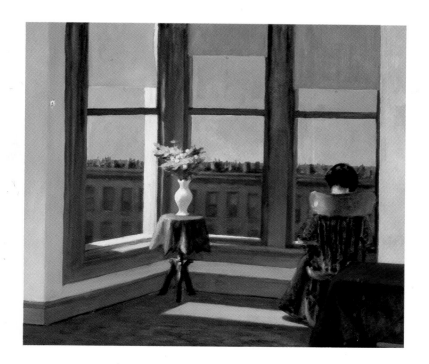

### Room in Brooklyn

*1932, oil on canvas; 29 x 34 in. (74 x 86 cm).*
*Museum of Fine Arts, Boston.*

Hopper's solitary figures of women by windows have often been interpreted by critics as embodiments of alienation. However, not all of Hopper's works of this kind can be so described. For example, *Room in Brooklyn* seems to convey solitude. The woman, whose back is turned away from the viewer, is engaged in a quiet activity; perhaps she is reading or looking out of the window at the street below. The bright sunlight and lovely floral arrangement resemble the paintings of William Merritt Chase, an American Impressionist painter.

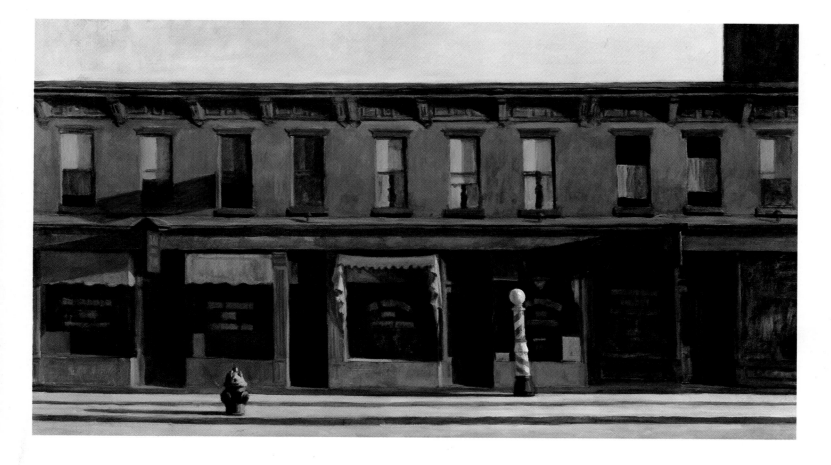

### Early Sunday Morning

*1930, oil on canvas; 35 x 60 in. (89 x 152 cm). Collection of Whitney Museum of Art, New York.*

In this work Hopper depicts the small businesses and shops of Seventh Avenue in New York City. The time is early morning, but the day is not necessarily Sunday, as that word was added to the title of the painting by someone other than Hopper. In 1930 Hopper had painted a figure in the second floor window, but later he painted it out. Jo Hopper recalled that this was a topic of discussion among the artists and critics of the period. Hopper may have felt that the architecture alone conveyed the feeling of the work.

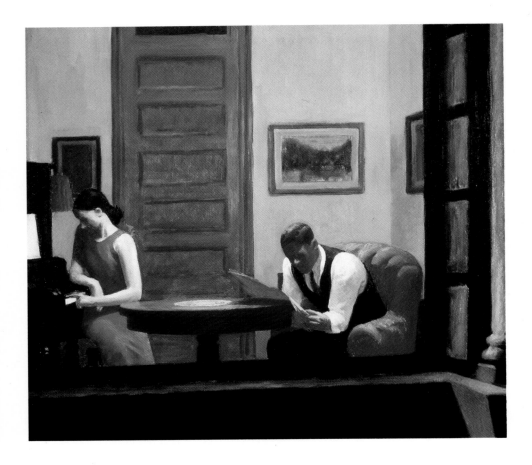

## Room in New York

*1932, oil on canvas; 29 x 36 in. (74 x 91 cm).*
*Sheldon Memorial Art Gallery and Sculpture Garden, University of Nebraska, Lincoln.*
The inspiration for *Room in New York* came from the lighted interiors Hopper
observed while walking at night through his Washington Square neighborhood.
The work is a synthesis of the many rooms he had viewed over an extended
period of time. Hopper's intentional blurring of the facial features of the
couple is a reminder to his audience that the role of the voyeur gives only
a glimpse, not an in-depth understanding, of the lives of these individuals.

## New York Movie

*detail; 1939; oil on canvas; The Museum of Modern Art, New York.*
Hopper transforms the dark interior of a movie theater into a study of light and
makes use of many sources and intensities of illumination throughout the painting.
The area around the usherette is the most defined, and the brightness from the
wall fixture highlights the gold of her hair and delineates the contours of her body.
Given such prominence within the composition, her relative status may be inferred.

**Ground Swell**

*1939, oil on canvas;*
*36 x 50 in. (91 x 127 cm).*
*In the Collection of the Corcoran*
*Gallery of Art, Museum Purchase,*
*William A. Clark, Washington, D. C.*
Since childhood Hopper was
fascinated with boats and the sea.
When he was fifteen his father
gave him materials to build a cat-
boat. Although it never sailed very
well, Hopper did consider a career
as a naval architect. As an adult
he owned a boat, but later, at Jo's
insistence, he sold it. No doubt
*Ground Swell* reflects Hopper's
summers in New England on his
own boat and on those of others.

## Country Scenes

Ever since his days as a struggling illustrator in New York, Hopper saved his money so
that he could live in New England for a couple of months each year. After their marriage
in 1924, the Hoppers began to spend their summers on the New England coast. In 1933
they built a house in South Truro, Massachusetts, and in their later years, they spent half
the year on Cape Cod and the other half in New York.

Hopper's scenes of Cape Cod reveal the glory of summer days gone by and frequently
reflect his impressionistic concern with sunlight. In *Ground Swell* (1939), he depicts sail-
ing, a fascination of Hopper's ever since his childhood days. As an adult, Hopper owned
a sailboat. Jo, however, was fearful for his safety, and at her insistence he sold it.

Another subject of interest to Hopper was lighthouses. In his numerous renditions of
them, such as *The Lighthouse at Two Lights* (1929), he managed to capture the effects of
sunlight on these structures. Nonetheless, though Hopper's lighthouses may be bathed in
sunlight, they still convey the quality of alienation common to much of his work due to
the absence of figures.

## Restaurants and Leisure

Hopper's paintings of this period also portray the leisure activities of city life. A sub-
ject stemming from his affiliation with the Ashcan and Impressionist schools, restaurants
were a unique aspect of city life which provided the artist with a wealth of intriguing
scenes. In *New York Restaurant*, Hopper recreated the hustle and bustle of a restaurant

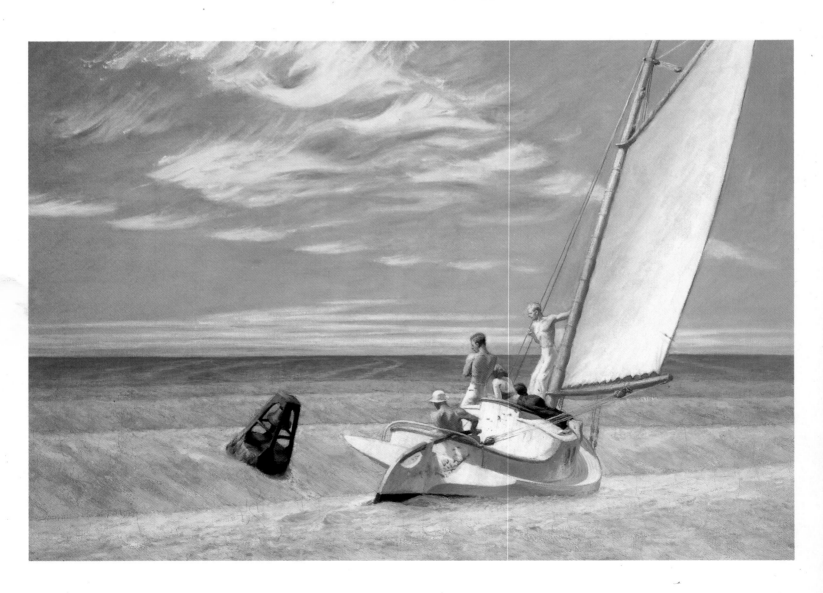

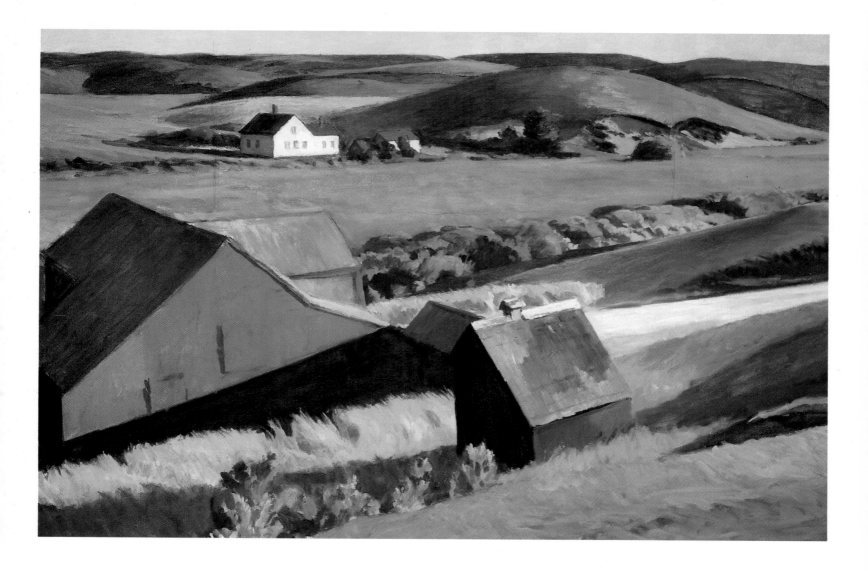

during a week-day lunch hour. His apparent aim in this work was to visually capture "the crowded glamour of a New York restaurant during the noon hour. I am hoping that ideas less easy to define have, perhaps, crept in also." Hopper incorporated an enormous amount of activity and many people into this painting, which was unusual for him to do.

*Automat* (1927) and *Tables for Ladies* (1930) are more characteristic of Hopper's mature style. These two works capture the alienation of the individual within a restaurant setting. One wonders why the cashier and waitress in *Tables for Ladies* do not interact, and whether they are both merely pensive or are bored with their situations. As always, Hopper leaves the narrative up to the viewer's imagination.

One of Hopper's most haunting images of loneliness in the city is *Nighthawks* (1942), a view of a diner at night. Hopper based the setting for this work on "a restaurant on Greenwich Avenue where two streets meet." In an interview with Katherine Kuh, Hopper commented: "*Nighthawks* seems to be the way I think of a night street. I didn't see it as particularly lonely. I simplified the scene

### Cobb's Barn and Distant Houses

*c. 1931, oil on canvas; 28 1/2 x 42 in. (73 x 107 cm).*
*Collection of Whitney Museum of American Art, New York.*
Hopper and his wife Jo liked to vacation on Cape Cod, and their many summers there enabled him to become intimately acquainted with the surrounding scenery. From 1930 to 1934 the Hoppers rented Burly Cobb's house in South Truro. Of his many paintings of Cape Cod, this view of Burly Cobb's farm is perhaps his finest. The bright colors of the landscape, bathed in sunlight, convey the warmth of a summer day in 1931.

*Following page:*
### The Lighthouse at Two Lights
*1929, oil on canvas; 29 x 43 in. (75 x 110 cm).*
*The Metropolitan Museum of Art, Hugo Kastor Fund, 1962, New York.*
Hopper painted the lighthouse at Two Lights near Cape Elizabeth, Maine, several times during the 1920s. For these paintings he worked outdoors, capturing the lighthouse bathed in bright sunlight against the clear blue sky

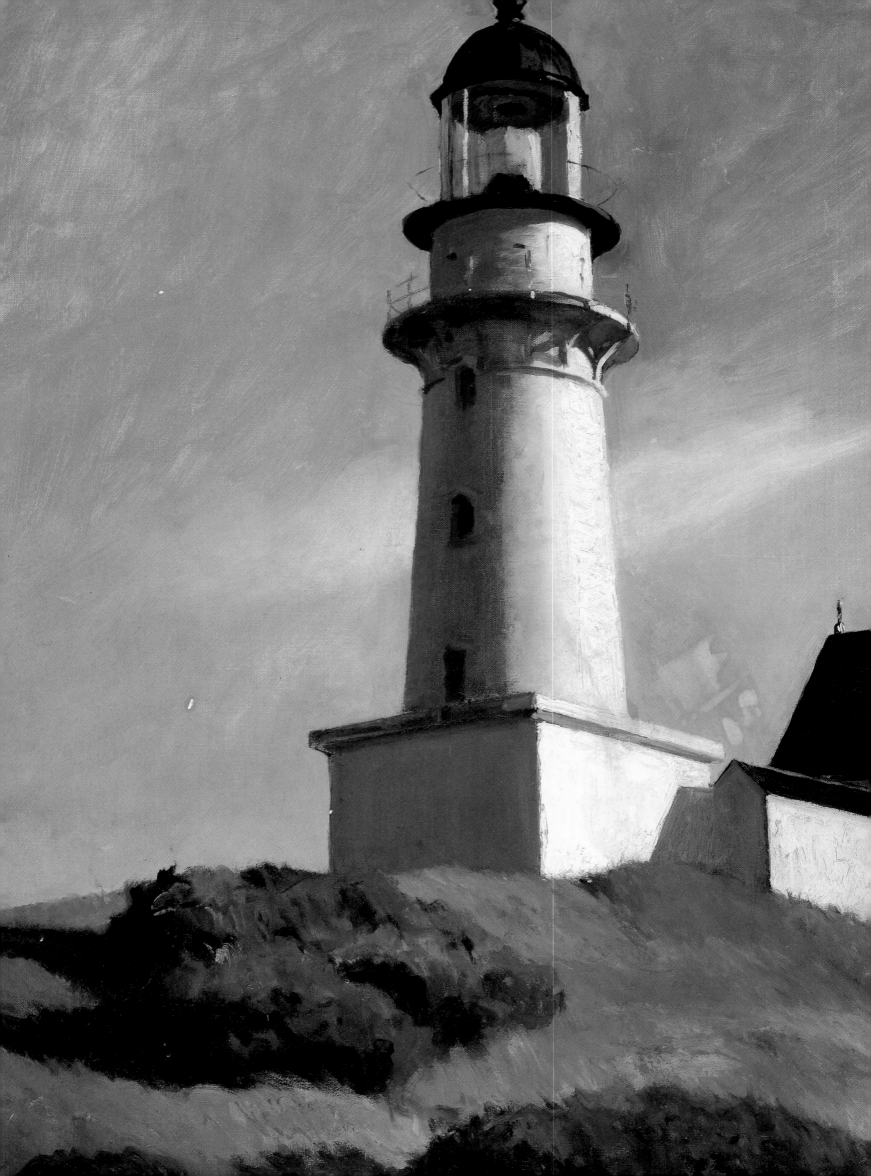

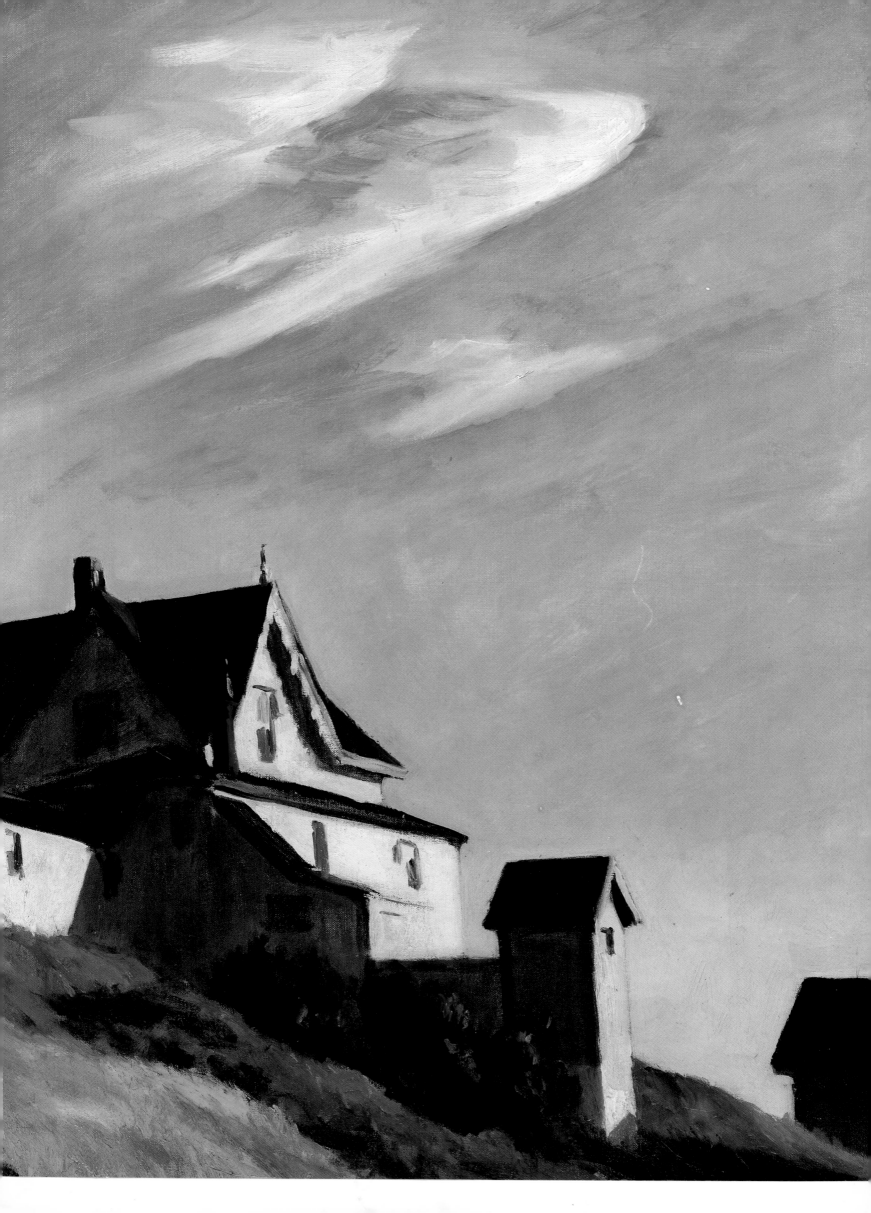

### Two on the Aisle

*1927, oil on canvas; 40 1/4 x 48 1/4 in. (102 x 123 cm.)*
*Toledo Museum of Art, Ohio.*
During the 1920s and 1930s, the Hoppers frequently
attended the theater. This period corresponds to the
emergence of such well-known playwrights as Eugene O'Neil,
Maxwell Anderson, and Elmer Rice. In *Two on the Aisle*,
Hopper presents a couple finding their seats prior to the
performance. The lack of communication between the two
is evident as the man looks away from his companion towards
the rest of the theater. The woman, stylishly dressed, places
her coat against her chair and looks down. To the right, in
box, a solitary woman reads her program before the show.

### First Row Orchestra

*1951, oil on canvas; 31 x 40 in. (79 x 102 cm).*
*Hirshhorn Museum and Sculpture Garden,*
*Smithsonian Institution, Washington, D.C.*
The Hoppers were avid fans of the theater throughout their
lives. When he used the theater as subject matter for his paint-
ings, Hopper chose to focus on the time before a performance
when the audience begins to assemble. The well-dressed couple
in *First Row Orchestra* represents the types of people he enjoyed
observing. Perhaps their quiet solitude and lack of interaction
appealed to Hopper, who was himself, primarily a loner.

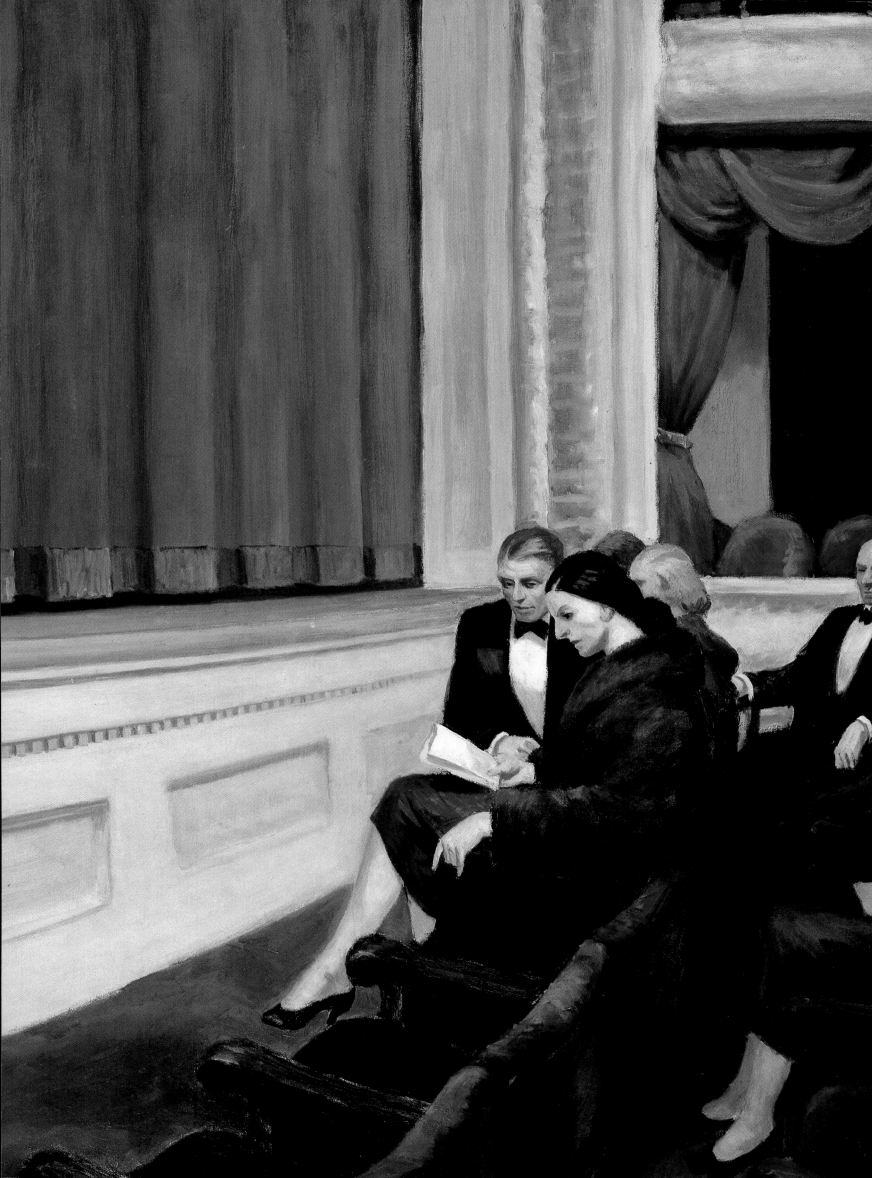

**The Sheridan Theatre**

*1937, oil on canvas; 17 x 25 in. (43 x 64 cm).
Collection of The Newark Museum, Purchase
1940 Felix Fuld Bequest Fund, New Jersey.*
Hopper visited the Sheridan Theatre
many times, coming away with numerous
preparatory sketches for this work.
Unlike the Ashcan artists who empha-
sized the gaiety and spectacle of stage
performances, Hopper's paintings of
the theater focus on the moments before
a performance and on the theatergoers
themselves. In this painting Hopper
emphasizes the architecture of the
theater as well as the isolation of the
woman leaning against the balustrade.

centrating on the spectacle on stage, he focused his attention on the spectators. More akin
to the theater-works of Mary Cassatt, Hopper painted the audience and the activities
prior to a show.

His *Two on the Aisle* (1927) and *First Row Orchestra* (1951) depict the time when the audi-
ence is beginning to assemble. Again, Hopper chose to illustrate the isolation of the indi-
vidual. Each audience member is lost in his or her own thoughts, busying him- or herself
with reading a program or gazing into space.

In the 1930s, movies became a popular pastime too, and Hopper enjoyed the escape
of a good film. With regard to his work habits, he once told Alexander Eliot, art edi-
tor at *Time* magazine: "I mostly walk around looking for ideas. I don't find many.
When I get too discouraged, I may drop in at a movie." One of Hopper's most
poignant works, *New York Movie* (1939), portrays the utter isolation of an usherette,
who stands against the aisle wall daydreaming or lost in thought. Ironically, moviego-
ing, one of the city's most popular leisure activities, bred further alienation and lack of
contact between people.

**Office Scenes**

Hopper's interest in office scenes may have derived from his days as an illustrator
when he drew various work spaces for *System* magazine. Levin has speculated that his

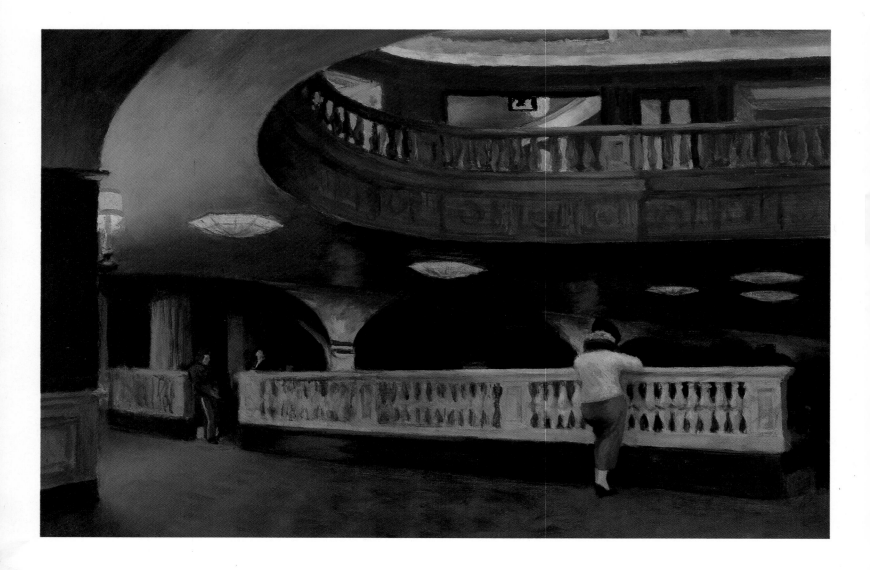

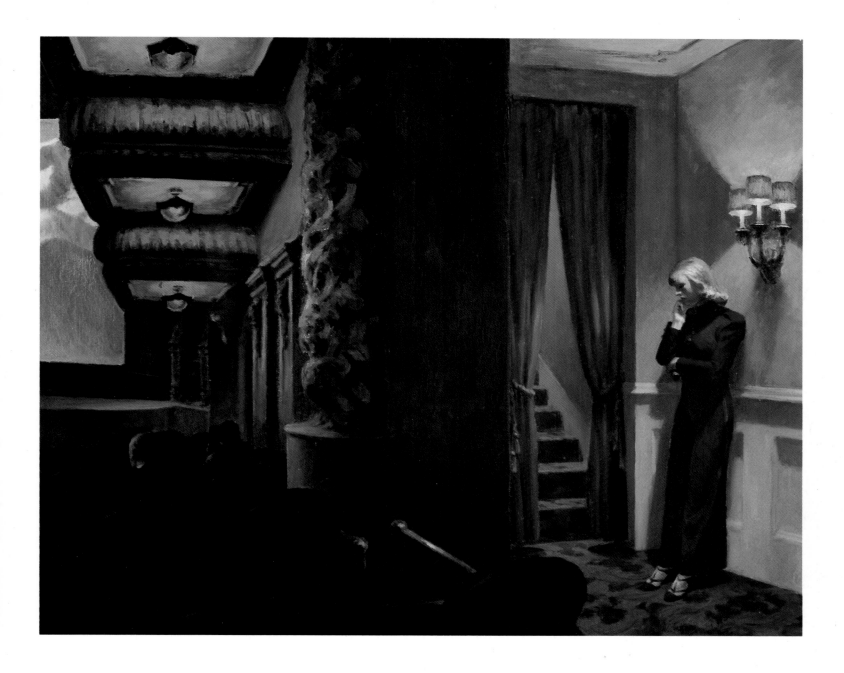

attraction to offices may also have resulted from his fascination with the art of Degas. Hopper owned two books on Degas, including the catalogue from the Degas exhibition at the Durand-Ruel Galleries in New York in 1928.

The compositional similarities between *Office at Night* (1940) and Degas' famous work of an office interior, *The Cotton Exchange, New Orleans* (1873), are too striking to be dismissed as coincidental. According to Levin, Hopper employed Degas' perspective, with his high view of the floor and the sharply angled glass window. Furthermore, the tension between the sexes in *Office at Night* is reminiscent of Degas' other office interior, *Sulking* (1869-71). Yet, while Hopper may have turned to Degas for compositional motifs,

## New York Movie

*1939, oil on canvas; 32 1/4 x 40 1/8 in. (82 x 102 cm).*
*The Museum of Modern Art, New York.*

Hopper enjoyed the escape of a good movie, and in the 1930s there were many movie theaters in New York from which to chose. As in his theater paintings, Hopper focuses his attention on the spectators. The sparseness of the audience indicates that the time of day is early afternoon, an-off hour for the movies. The young usherette is perhaps daydreaming, as she indeed must have seen this film many times before. Ironically, her own thoughts, not those suggested by the movie screen, have transported her to a different place. The isolation of this usherette in her setting is quite similar in sentiment to Édouard Manet's *A Bar at the Folies-Bergère*.

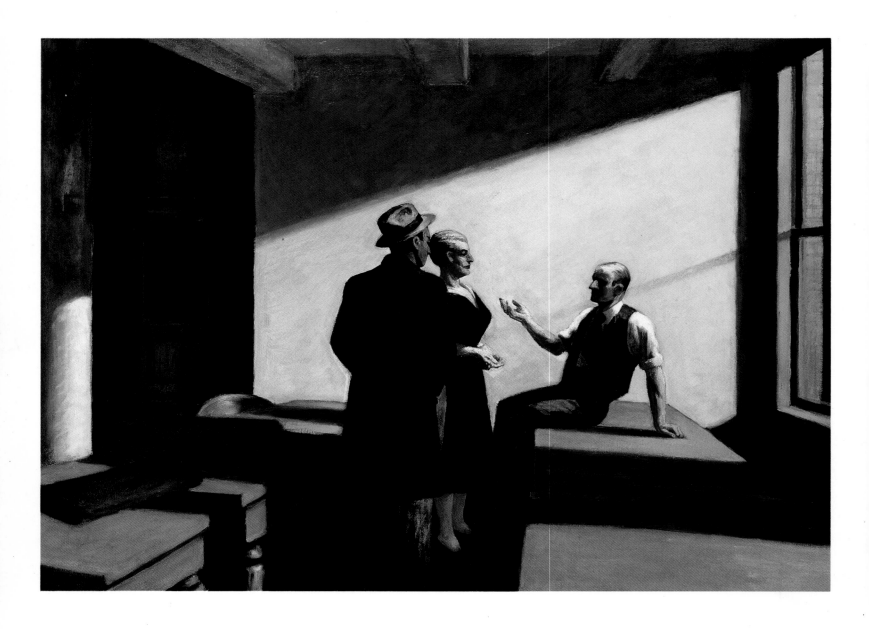

## Conference at Night

*1949, oil on canvas; 27 3/4 x 40 in. (70 x 102 cm).*
*The Roland P. Murdock Collection, Wichita Art Museum, Kansas.*
Of all Hopper's varied office scenes, *Conference at Night*
is unique because the characters in the painting interact
with each other. The clandestine nature of this night
meeting suggests the darker side of the human psyche.
Why are these people meeting after hours? Hopper's
characters would fit well into a *film noir* screenplay, and
the observer can't help but speculate that they are up to
no good. In addition, the docile secretary of *Office at
Night* has been replaced by a coarse, dominant female who
appears to be on equal standing with her male counterparts.

the idea behind this work is Hopper's own. It originated one night as he
was peering into office windows while riding the elevated subway.
Hopper explained his intentions in this painting in a letter to the Walker
Art Center: "My aim was to try to give the sense of an isolated and lone-
ly office interior rather high in the air, with the office furniture which has
a very definite meaning for me."

The interaction of the boss and his secretary in *Office at Night*, and the
gender tensions that apparently exist between them, has sparked much
controversy in art-history literature. A highly plausible interpretation of
the relationship between the two was suggested by Ellen Wiley Todd,
who studied the cultural role of the secretary in the 1940s. Todd believed
that Hopper's audience at the time would have viewed this woman as
being in an exalted position, and that she was appropriately dressed for
her role in the office. Yet Hopper does not tone down her sexuality; if
anything he has increased it. Although the secretary appears to have
power within the office, she nonetheless is restricted by her position, as

she must wait for orders from her boss. This painting portrays the dichotomy of her situation: the secretary is both respected for and limited by her femininity.

*Conference at Night* (1949) displays a contrasting aspect of the woman's role in the 1940s. In another nocturnal scene, the woman in this office appears to be on a par with her supposed superiors. However, the clandestine nature of this meeting indicates that perhaps the participants are up to no good. This feeling is enhanced by the painting's sinister atmosphere which recalls the evocative lighting of the movie genre *film noir* with its telling use of light and shadow to convey a sense of menace.

**Office at Night**
*1940, oil on canvas; 22 1/8 x 25 in. (71 x 64 cm).*
*Collection of Walker Art Center,*
*Gift of T. B. Walker Gilbert M. Fund, 1948, Minneapolis.*
Hopper's interest in offices as subject matter stems from his years as an illustrator, during which he depicted work spaces for *System* magazine. In a letter to the Walker Art Center explaining the creation of this work, Hopper stated that he had conceived *Office at Night* while riding the elevated train, or "el," where he caught glimpses of office interiors. He meant for his work to capture the lonely and isolated atmosphere of these places.

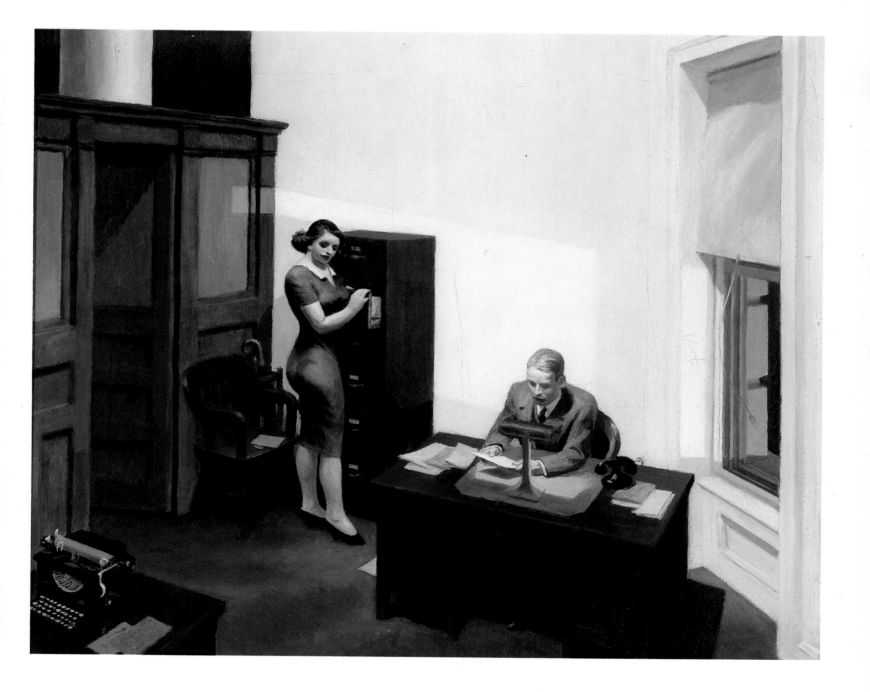

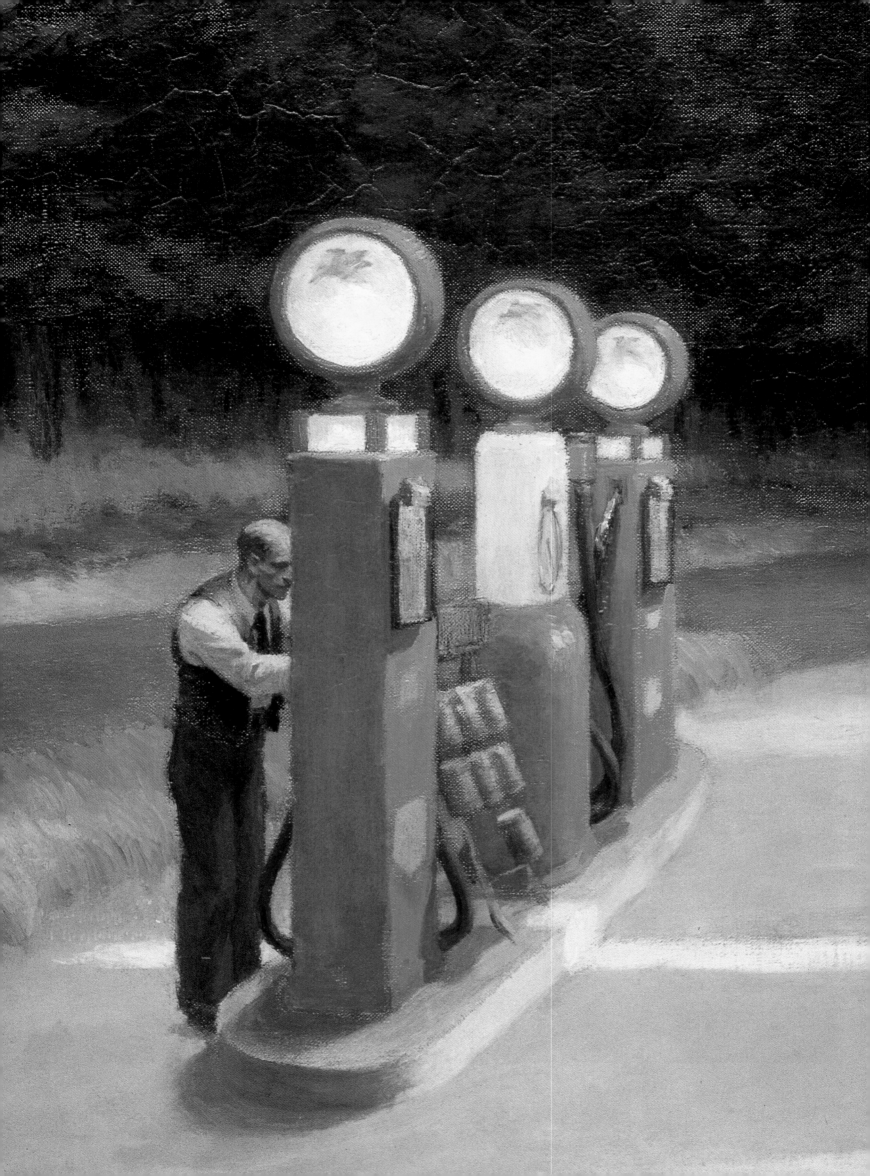

# NEW MODES OF TRANSPORTATION: AUTOMOBILES AND TRAINS

*I*n the late 1920s, the American travel industry boomed. The most popular modes of transportation during this period were trains and automobiles. According to Hobbs, car registrations in America nearly tripled in the decade of the twenties, reflecting the ownership of over thirty-one million cars and four and a half million trucks in the United States.

The automobile, the newest mode of transportation, would considerably change the face American life. Roads, highways, gas stations, and motels all had to be built to service the needs of the ever-increasing number of drivers. Furthermore, cars and trains granted people greater freedom to travel and explore the country. Yet at the same time, as Hobbs explained, their view of the landscape became limited by their mode of travel. People's perceptions of the American countryside were increasingly restricted to what they saw from car and train windows—images of progress such as roads, signs, gas stations, and railroad tracks.

In 1927, the Hoppers joined the increasing number of American car owners. They purchased a Dodge. With the acquisition of their new auto, the Hoppers' proclivity for taking trips grew. Throughout the thirties and forties, whenever Hopper would get restless, he and Jo would get in their car or on a train. In addition to traveling throughout New England, the couple visited Mexico and the southern and western parts of the United States.

With the growth of the travel industry, Hopper was exposed to a whole new area of subject matter. His art from the late twenties onward reflects his increasing interest in this phenomenon. It is remarkable how many

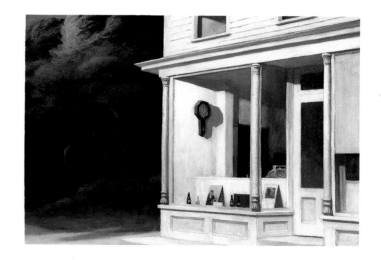

### Gas

*detail; 1940; oil on canvas;*
*The Museum of Modern Art, New York.*
Hopper sought to create the perfect gas pump for this composition. The one in this work is therefore a composite of many pumps in different filling stations he came across during his travels. At the time this work was created Hopper took a benign view of the extension of modern life into the rural landscape. However, later on he changed his attitude as he saw the full effects of industrial society upon the natural world.

### Seven A.M.

*1948, oil on canvas; 30 x 40 in. (76 x 102 cm).*
*Collection of Whitney Museum of American Art, New York.*
The rural counterpart to *Early Sunday Morning*, this work portrays Hopper's interest in small businesses. The varied objects in the shop window might suggest a curio shop, but the true nature of its business is quite elusive. Hopper places the scene in the early morning hours when the streets are still deserted. The homey, familiar atmosphere of the shop stands in contrast to the dark overgrown woods behind it.

of Hopper's paintings from this period and later concern travel or the traveler. Evidently, Hopper was particularly interested in the psychology of travelers within their surroundings. His astute observations of human behavior in hotel rooms, lobbies, and trains permanently document the changes that occurred in America during this time. Furthermore, Hopper's travel paintings continue a theme already established in his city scenes—alienation—with the same cold isolation found in his urban pictures. Often taking the viewpoint of the traveler, Hopper's paintings of this period reflect the transient, disjointed connection humans had with their rapidly modernizing environment.

## Scenes From Trains

Hopper's fascination with travel was not without foundation. His art displayed an interest in trains and railroad tracks well before the 1920s. As a child growing up in Nyack, Hopper repeatedly sketched trains, and during his student days at the New York School of Art, he explored the train as a subject in both *El Station* (1908) and *Railroad Station* (1908).

The "train pictures" that Hopper painted as an adult, however, are less focused on the train itself and more concerned with the encounters one might have while traveling. Additionally, the artist was intrigued by the scenery fleetingly observed while riding in a passenger car. For example, his glorious *Railroad Sunset* (1929) is a view one might have seen from a speeding train.

**Railroad Sunset**

*1929, oil on canvas; 28 X 47 in. (72 x 121 cm). Collection of Whitney Museum of American Art, New York.*

Hopper's impressionist interest in times of day may have lead him to the subject of a railroad sunset. The varied ranges of colors that accompany the setting sun are masterfully rendered. Additionally, the absence of human life lends a melancholy note to the work, as the beauty of the moment goes unnoticed.

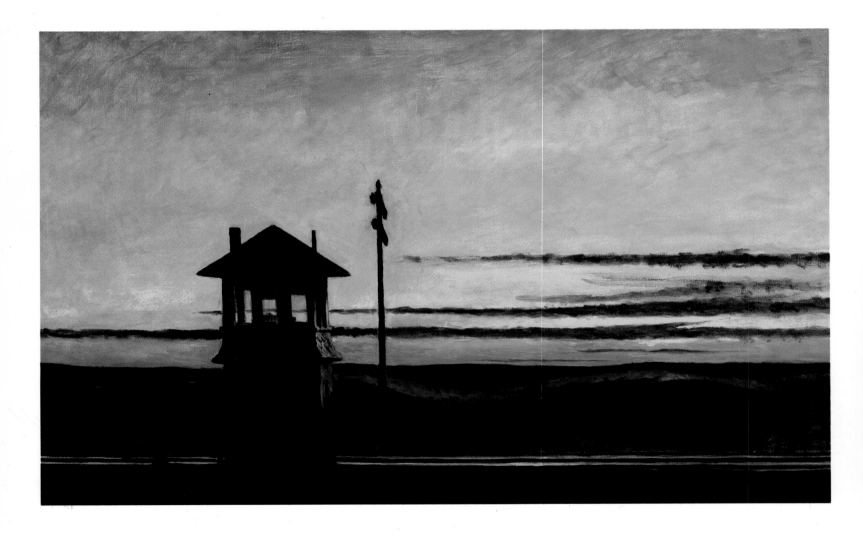

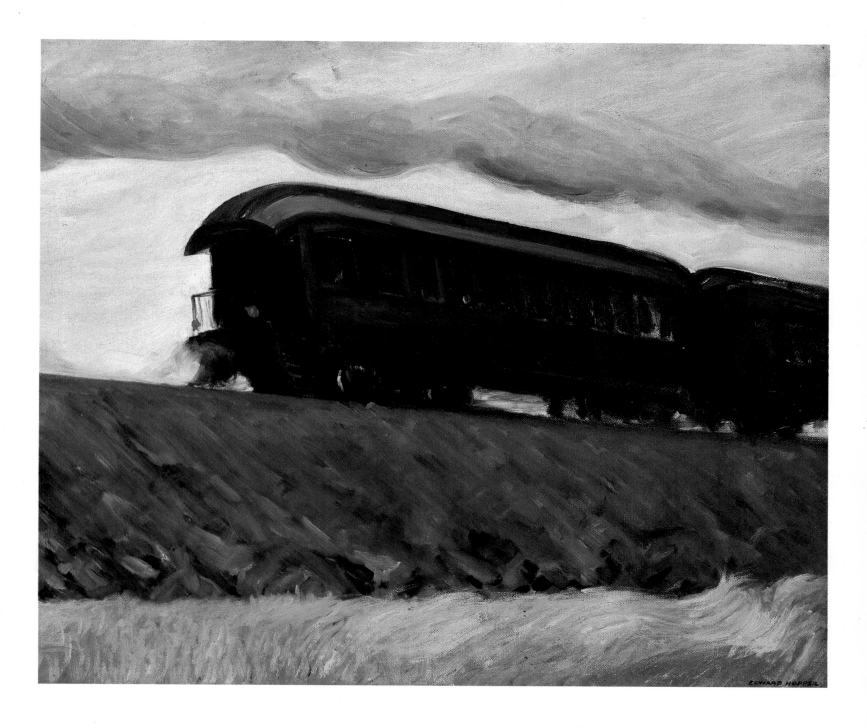

The barren and desolate ghost towns of rural America, as seen from train cars, also interested Hopper. In *House by a Railroad* (1925), he depicted a seemingly abandoned Victorian-style house by the railroad tracks. The inclusion of train tracks, a common motif in Hopper's travel pictures of this period, are, according to Levin, reflective of "the continuity, mobility, and rootlessness of modern life as they merely pass by small towns and rural areas all but forgotten by the forces of progress."

Hopper's observations of train interiors are equally probing. The solitary woman engrossed in her reading in *Compartment C, Car 293* (1938) is oblivious to the passing landscape outside her window. Hopper's preliminary sketches for this work reveal that the artist had originally intended the woman to be looking

**Railroad Train**

*1908, oil on canvas; 24 x 29 in. (61 x 74 cm).*
*Addison Gallery of American Art, Phillips Academy,*
*Andover, Massachusetts.*

The train car in this painting was perhaps inspired by Hopper's daily commute from Nyack to New York City. The dark palette and sketchy brushstrokes reflect the influence of the Ashcan School on Hopper's art during this period.

out the window. Yet for the final version, he instead chose to have her read, an act which Levin suggests adds to the introspective nature of the composition.

*Chair Car*, painted in 1965, explores the isolation and lack of interaction between four passengers inside a sunny train car. Hopper's use of sunlight in this work serves as a barrier to further separate these individuals from one another. The woman in red will never engage the attention of the reading woman, nor of any other passenger in the car.

## Automobiles

America, as viewed from Hopper's automobile, was changing rapidly. His paintings of gas stations and highways, unusual subjects in art history, seem to reflect the artist's own internal conflict with America's progress. Hopper's fascination with filling stations led him to paint several works on this subject. Apparently, he studied many gas pumps before creating those in *Gas* (1940), which depicts a seemingly brand-new Mobil station. The station, with its artificial lights and pristine cleanliness, appears to be an oasis of comfort for the weary traveler. This sense of hospitality is further evoked by Hopper's portrayal of nature as an overgrown forest, made all the more menacing by the approach of nightfall. Nonetheless, a feeling of loneliness pervades the work, as the solitary attendant waits for his next customer.

**The El Station**

*1908, oil on canvas;*
*20 x 29 in. (51 x 74 cm).*
*Collection of Whitney Museum*
*of American Art, New York.*
Hopper painted this work shortly after returning from his first European trip. New York's elevated train held a particular fascination for him, and many of his mature works, such as *Office at Night*, were inspired by the brief glimpses into rooms and offices he had while riding these trains during the late-night hours.

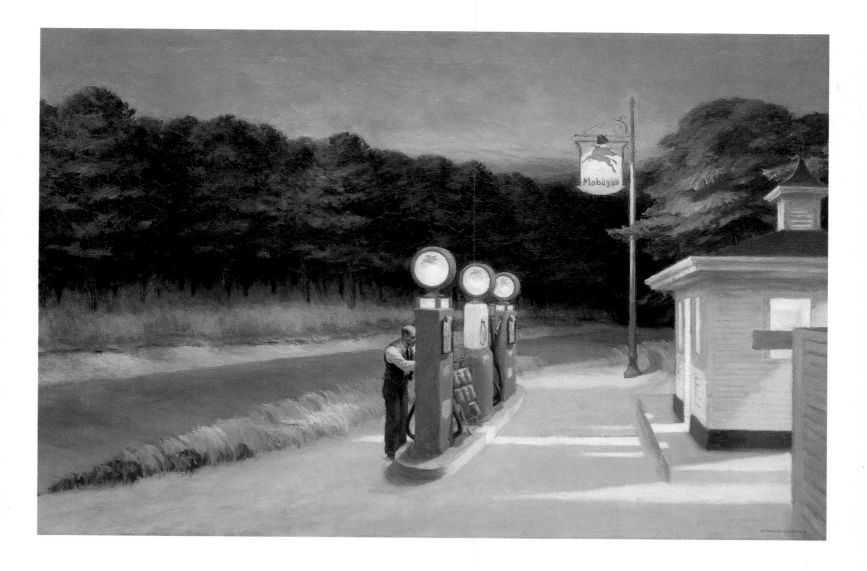

The roads Hopper passed while driving his automobile are forever recorded in works such as *Route 6, Eastham* (1941) and *Solitude* (1944). In these paintings, the artist captured the vast emptiness of endless highways and roads and the invasion of progress into the remote rural countryside.

The prospect of a night's rest after a long day of driving is the subject of Hopper's *Rooms for Tourists* (1945), evidently based on an actual boardinghouse in Provincetown, Massachusetts. Hopper's preliminary drawings for this work were executed while seated in his car. His decision to do this was, as Hobbs explains, intentional; the artist was determined to take the viewpoint of the tourist who, having arrived at a boardinghouse by car, now wonders if the lodgings will be suitable.

Hopper's intimate portrait *Jo in Wyoming* (1946) further evidences his use of views from his automobile as a context for his subject matter. This work reveals the manner in which Hopper may have arrived at his perspectives of roads and gas stations. The painting

**Gas**
*1940, oil on canvas; 26 1/4 x 40 1/4 in. (67 x 102 cm).*
*The Museum of Modern Art, New York.*
The automobile radically changed rural America during the decade of the 1920s. Highways, gas stations, and motels were built across the country to serve the needs of the automobile and those who traveled in it. In *Gas* Hopper portrays this invasion of modernization into the rural countryside. The pristine newness of the Mobil gas station contrasts with the wilderness in the distance.

*Following page:*
**Pennsylvania Coal Town**
*1947, oil on canvas; 28 x 40 in. (71 x 102 cm).*
*The Butler Institute of American Art, Youngstown, Ohio.*
A solitary figure raking leaves is the subject of this painting. The features of the man look quite similar to the man in *Sunday*, a work painted twenty-one years earlier. The seeming re-use of characters from earlier works fits into Hopper's and Jo's game of naming characters in his paintings and creating stories for their lives.

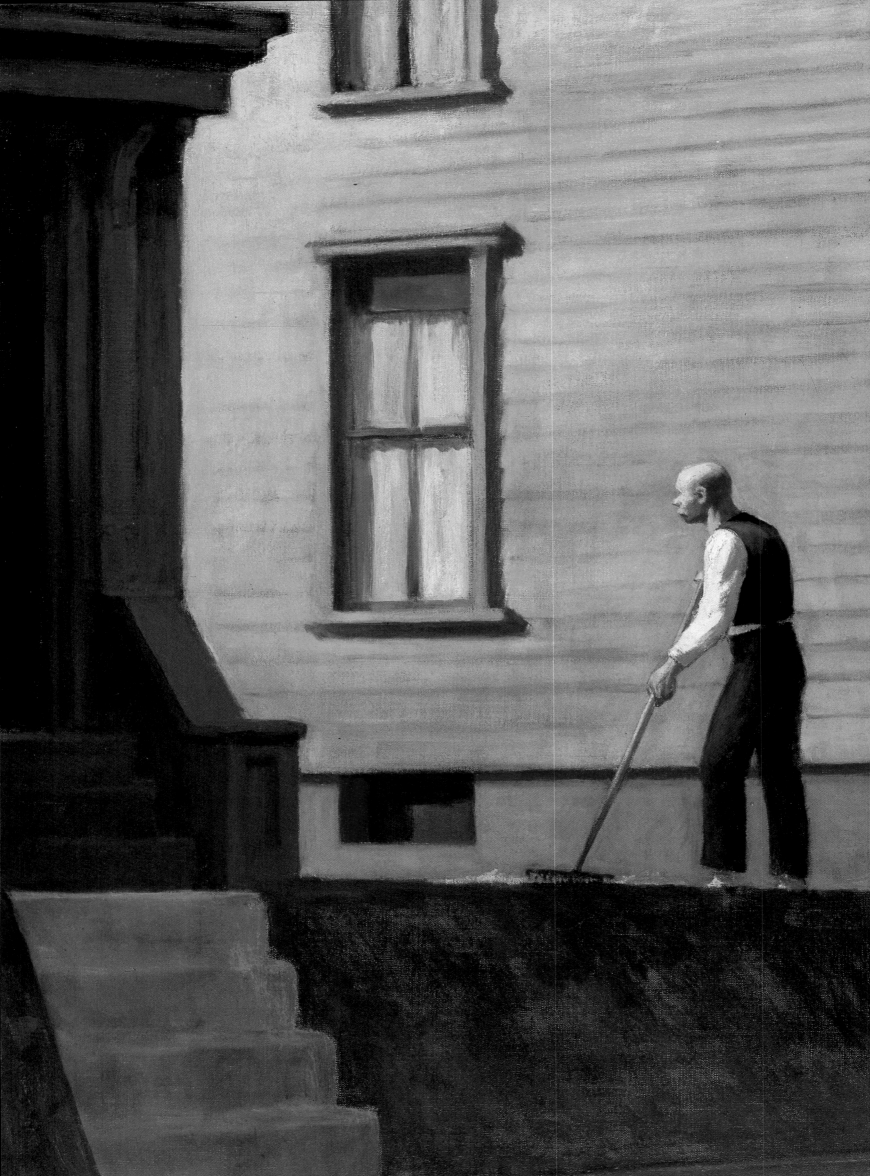

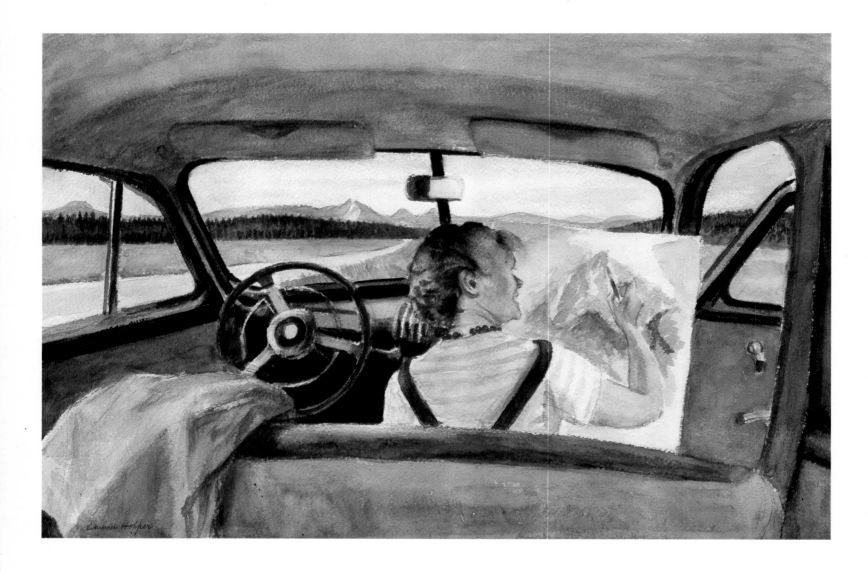

## Jo in Wyoming

*July 1946, watercolor on paper;*
*13 15/16 x 20 in. (33 x 51 cm).*
*Collection of Whitney Museum of Art, New York.*
Hopper's portraits of Jo are intimate glimpses
into the couple's personal life. In 1946 the
Hoppers traveled in the West. This water-
color records a moment from that trip—Jo
painting the mountains of Wyoming from
an automobile. His vantage point, portraying
Jo from behind, reflects his own use of the
automobile as a window through which he
viewed the rural countryside of America.

depicts Jo sketching the mountains in Wyoming. However, her view of the
landscape is from their car, and consequently her experience of Wyoming's
mountains is limited.

## Hotels

Many of Hopper's most poignant dramas are found in depictions of people in
hotel bedrooms and lobbies. The psychology of the traveler intrigued Hopper,
and he and Jo must have enjoyed creating stories about the lives of the people
they met while traveling. The subject matter of Hopper's hotel pictures fre-
quently reflects this fascination with inventing tales, often displaying a charac-
teristic common to many of his mature works: the capturing of a moment just
after something has seemingly occurred. This predilection for painting the
aftermath of situations might also account for the frozen stiffness of Hopper's
compositions.

In *Hotel Room* (1931), a young woman sits pondering a letter that seems to have
caused her considerable pain. The isolation of this young woman is as perplexing
as the contents of the letter are unclear. Perhaps she has been disappointed in love
or is running from something or someone. Regardless of her story, Hopper leaves
the viewer to glean his or her own personal meaning from the work.

One senses that something has just transpired between the elderly gentleman and the old woman seated next to him in Hopper's *Hotel Lobby* (1943). The woman, presumably his wife, looks up at the man as if to continue an argument, but he looks blankly ahead, ignoring her presence. Towards the end of the lobby, a blond woman, seemingly oblivious to what has occurred, is reading. The lack of interaction between all the principal characters in this painting highlights the alienation and coldness of the hotel lobby.

In Hopper's preliminary drawings for the work the elderly couple was conversing, and the reading woman was originally a man staring across the room. It is probable that these early sketches depict actual people Hopper saw during his travels with Jo. He then used these drawings for his studio composition, eliminating some aspects of his observations while keeping others. His changes reveal how the artist created drama and illusion in his paintings. Time and again,

### Rooms for Tourists

*1945, oil on canvas; 30 x 40 in. (76 x 102 cm).*
*Yale University Art Gallery, New Haven.*
The commonplace idea evoked by this scene, the renting of rooms, appeals to the traveler within us all. The subject of this painting may actually have occurred to Hopper in his automobile while traveling with Jo in New England. The warmth of the Victorian house—perhaps a bed and breakfast—contrasts against the dark night and may well have been a welcome sight for a weary traveler.

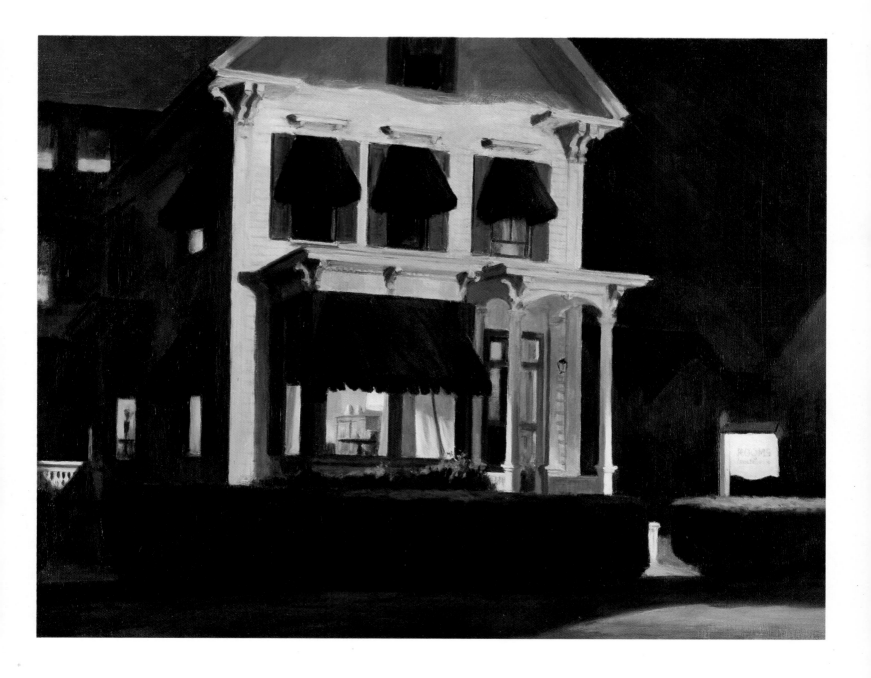

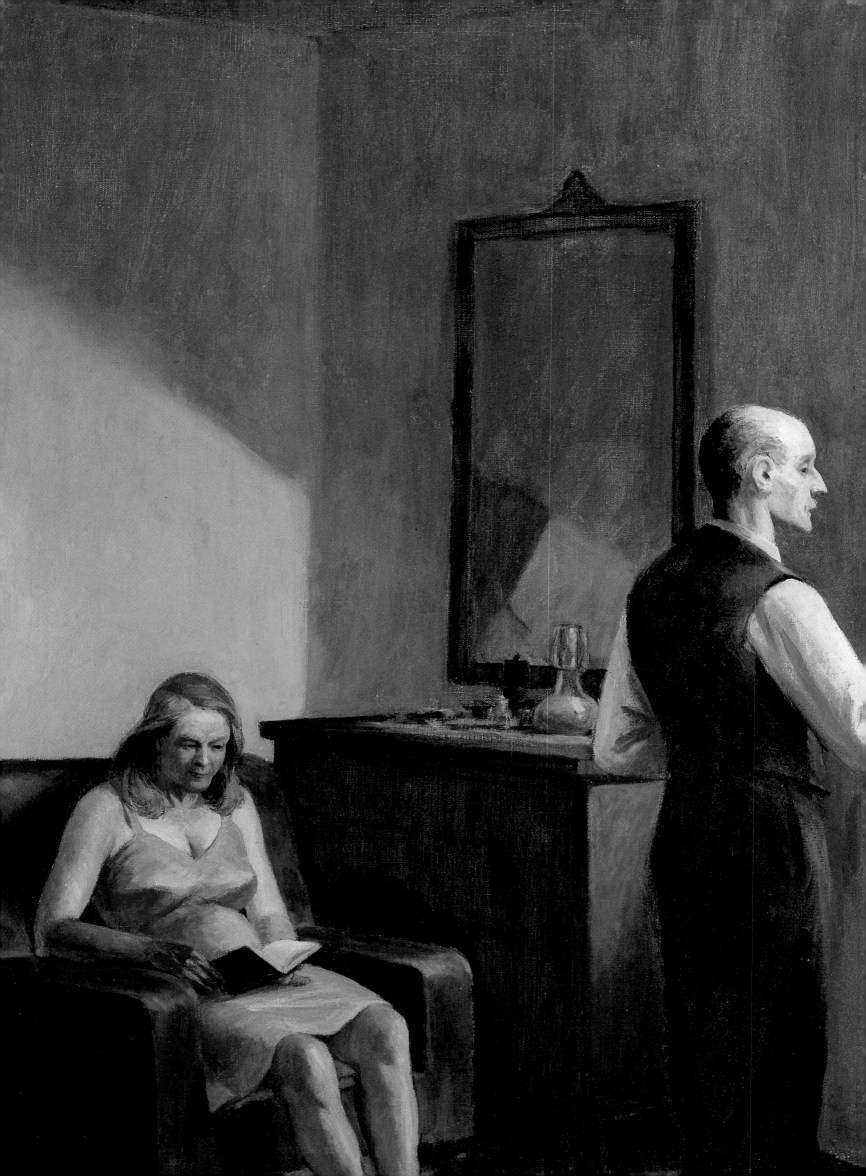

**Hotel by a Railroad**
*1952, oil on canvas;*
*31 x 40 in. (79 x 102 cm).*
*Hirshhorn Museum*
*and Sculpture Garden,*
*Smithsonian Institution,*
*Washington, D. C.*
The emotional distance
that occurs within a rela-
tionship is a theme often
characterized in Hopper's
paintings. In *Hotel by a
Railroad* Hopper depicts
a middle-aged couple,
who appear to be quite
removed from each other.
Both of these individuals
seem to be seeking escape;
he by glancing out the win-
dow towards the railroad
tracks, and she by reading
a book. Their escape may
be from each other as
well as from the drab
lifestyle they seem to share.

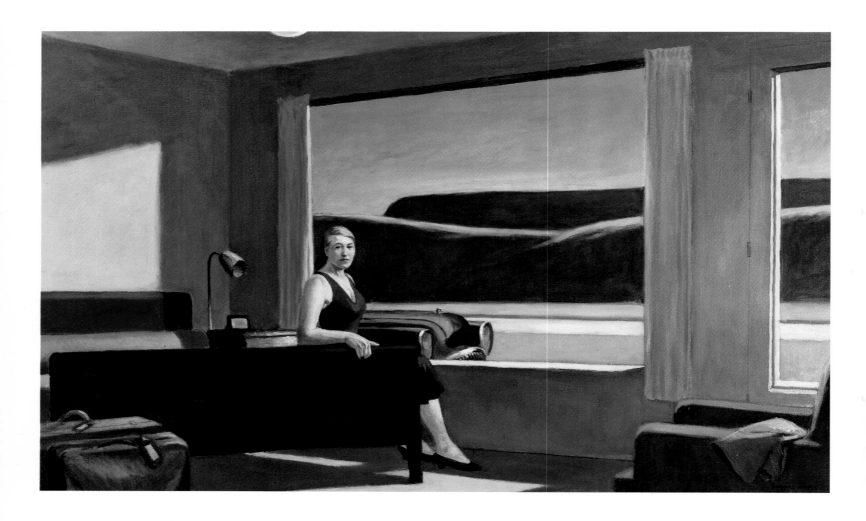

### Western Motel

*1957, oil on canvas;*
*30 1/4 x 50 1/8 in. (77 x 127 cm).*
*Yale University Art Gallery, New Haven.*
In the 1950s the Hoppers traveled to
California and Mexico. These trips
provided material for such paintings as
*Western Motel.*

Hopper chose to emphasize the lack of communication between the characters in his paintings.

The effects of a transient lifestyle on middle-class America are dramatized in Hopper's painting *Hotel by a Railroad* (1952). Again, the viewer is faced with a middle-aged, non-communicating couple. Both figures are preoccupied with their own thoughts. The man holding a cigarette stares out the window towards the railroad tracks, appearing to wish he were elsewhere, and the woman engaged in reading has found a similar escape.

*Western Motel* (1957) is perhaps Hopper's most critical statement on America's changing modes of travel. By the 1950s, the familiar sights of motels, highways, gas stations, and train tracks were invading even America's rural countryside. According to Hobbs, the picture-postcard effect of *Western Motel* alludes to the fact that travel was becoming nothing more than a collected series of snapshots and postcards. The seated woman experiences very little of the western expanse as she moves from motel room to car to highway. Her perception of the West is confined to what she sees outside her motel and car windows.

The images of America depicted in Hopper's initial travel paintings are twentieth-century descendants of the works of the Hudson River School.

Artists of this school, such as Asher B. Durand, did not necessarily view man's progression into the wilderness as threatening to nature. Durand's *Progress* (1853) is a positive statement on the harmony that could exist between man's advancement and nature. Likewise, Hopper's early travel pictures, such as *Gas*, depict a peaceful coexistence between progress and nature, akin in spirit to Durand's *Progress*. Hopper's later works, however, reveal a change in attitude towards modernization as the western landscape, once considered exotic and grandiose, is now, in *Western Motel*, domesticated and familiar to every suburban dweller of the period.

**Office in a Small City**
*1953, oil on canvas; 28 x 40 in. (71 x 102 cm).*
*The Metropolitan Museum of Art, George A. Hearn Fund, 1953, New York.*
Hopper portrays a man looking out of his office window, perhaps daydreaming or longing to be somewhere else. Hopper must certainly have identified with this situation, since in the early years before his professional success, he was forced to make his living as an illustrator. He abhorred this work and felt it took him away from his true vocation, painting.

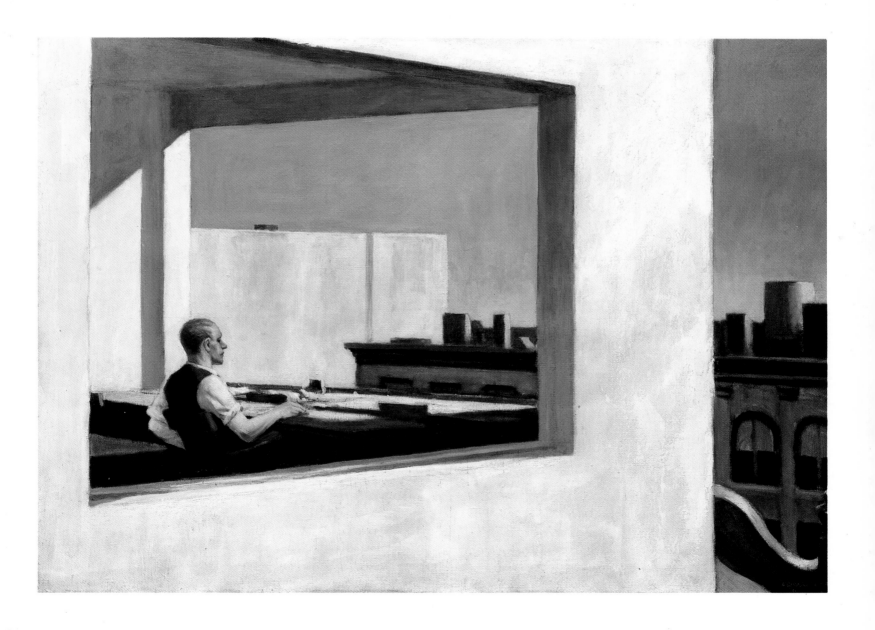

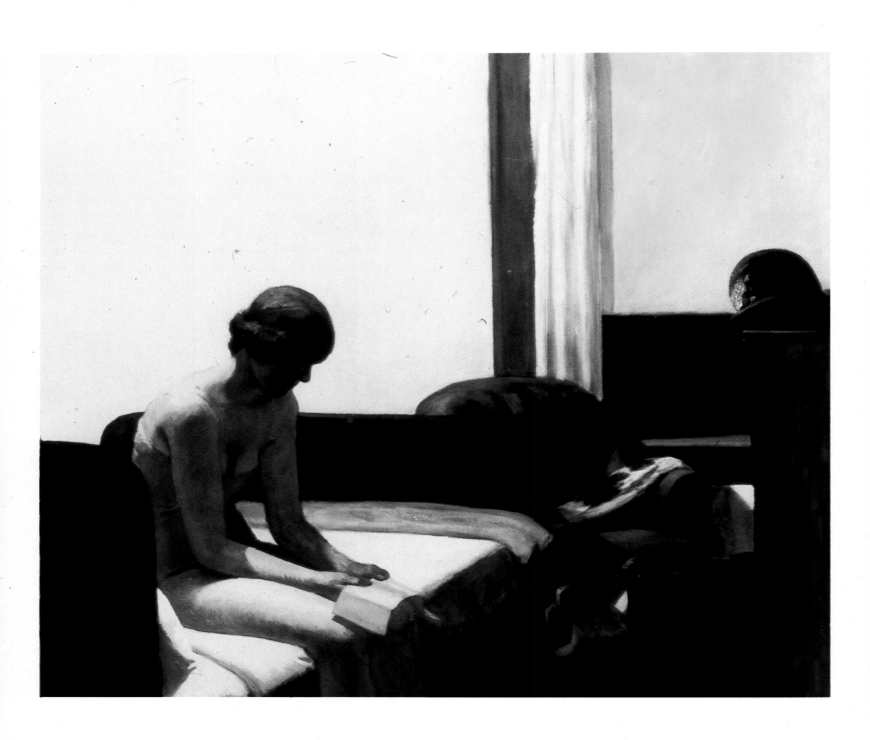

## Hotel Room

*1931, oil on canvas; 60 x 65 in. (152 x 165 cm).*
*Museo Thyssen-Bornemisza, Madrid, 1995.*

Hopper was fascinated with the psychology of travelers. While he
never returned to Europe after 1910, Hopper and Jo traveled extensively
in Mexico, New England, the South, and the far West. As his paintings
of hotel rooms suggest, Hopper recognized the universal loneliness
of the traveler. In fact, here the isolation of the woman is all the
more poignant because of the transient nature of the hotel room. The
drama of this painting lies in the letter the young woman is holding,
the content of which Hopper leaves to the imagination of the viewer.

## Western Motel

*detail; 1957; oil on canvas;*
*Yale University Art Gallery, New Haven*

As the picture postcard effect of the mountain scenery
outside the window suggests, this woman only sees the
landscape through the eyes of a tourist. Her situation is
enigmatic. She appears to be waiting, but though the
packed bags and the car outside are clues, it is unclear
whether she is about to depart or has just arrived. She
stares straight forward, making eye contact with the viewer,
or perhaps with the person for whom she has been waiting.

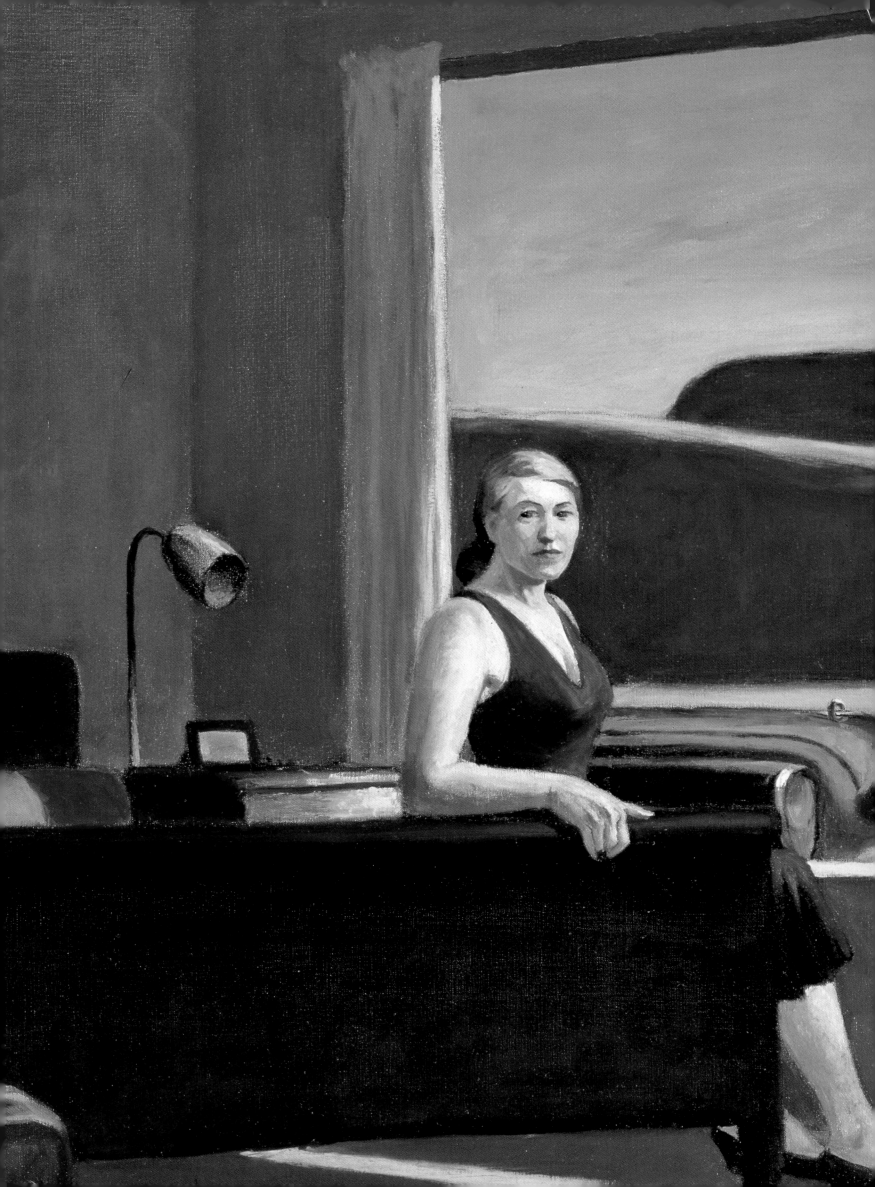

# LATE WORKS: SUNLIGHT AND A FINAL BOW

The paintings Hopper executed during the last fifteen years of his life emphasize his fascination with light, particularly sunlight. This was not a new interest for the artist. It was a subject that had concerned him since his student days in Paris in the early 1900s. Describing this lifelong attraction, Hopper once said, "What I wanted to do was paint sunlight on the side of a house." In his late works, he tended to let sunlight dominate his canvases. His works of this period, however, differ from those of the Impressionists in that Hopper never allowed his rendering of light to diffuse the physical reality of the objects in his compositions.

The reemergence of sunlight in Hopper's late works may be due in part to his advancing age. In the 1950s the Hoppers' interest in grand adventure waned, and they spent more time at their home on Cape Cod. The

**Cape Cod Evening**
*1939, oil on canvas; 30 x 40 in. (77 x 102 cm).*
*National Gallery of Art, John Hay Whitney Collection,*
*©1995 Board of Trustees, Washington, D.C.*
The impetus for this scene comes from the call of a
whippoorwill or some other sound that has interrupted
the stillness of the quiet evening. The collie turns from
his owners to determine the origin of the sound. In Hopper's
ledger book, the artist described the woman in the painting
as a Finnish type, common to the Cape, and the man as a
dark-haired Yankee. Hopper did not intend the work to be
an exact transcription of a place, but rather a series of many
impressions of Cape Cod gathered over a period of time.

## Rooms by the Sea

*1951, oil on canvas; 29 x 40 in. (74 x 102 cm).*
*Yale University Art Gallery, New Haven.*
The Hoppers had a wonderful view of
the sea from their summer home in South
Truro, Massachusetts. However, the surrealis-
tic quality of this painting suggests that
Hopper was not inspired by any particular
situation he had observed. In a move away
from reality, he has depicted a home by
the sea devoid of people. The front door
leads right into the ocean. Perhaps, this is
Hopper's ultimate joke on the excess of
conveniences in modern society. His painting
recalls the work of Magritte, and it is perhaps
his first and last excursion into surrealism.

powerful sunlight and clear blue skies of the Cape intrigued the painter and
inspired many of his works from this period. Additionally, as Hobbs has speculat-
ed, America's new pastime of sunbathing may have contributed to Hopper's
renewed interest in sunlight. Many of his pieces from the late 1950s onward depict
sunbathers.

## Cape Cod

The Hoppers' summer house in South Truro, built in 1934, was a simple wooden
structure located on the beach. Hopper designed the house himself with large win-
dows, which enabled him to paint outdoor scenery from inside his studio. As the artist
spent more time in the South Truro studio in his later years, he increasingly found
subject matter from the spectacular views he observed through his windows. *Rooms by
Sea*, painted in 1951, was inspired by the close proximity of the Hoppers' summer
home to the beach. In an uncharacteristic departure from reality, he depicted an open
door leading directly into the ocean. Sunlight pours into the room from the doorway,
creating an abstract patch of light on the floor. The fantastical quality of the work is

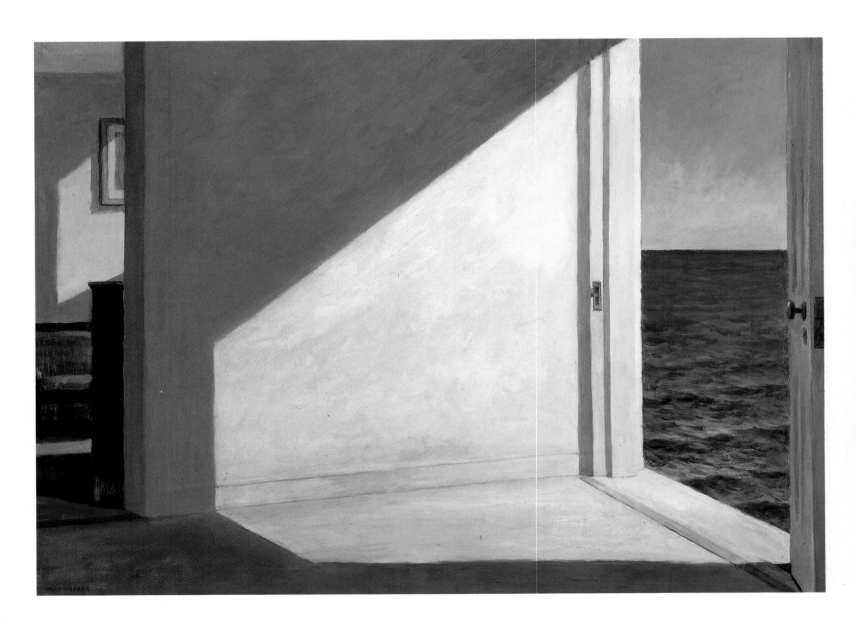

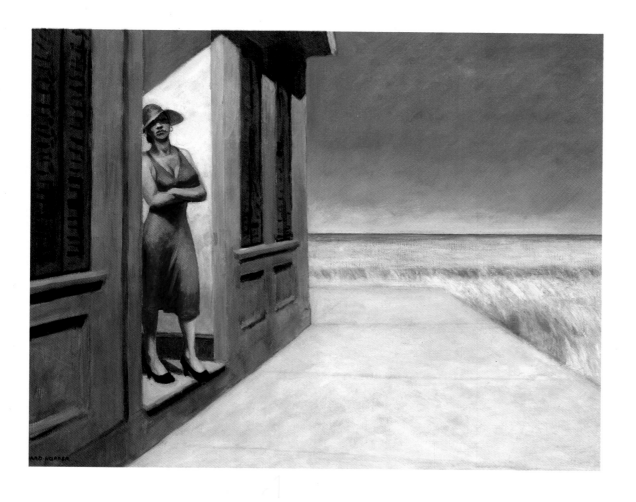

## Carolina Morning

*1955, oil on canvas;*
*30 x 40 in. (76 x 102 cm).*
*Collection of Whitney Museum*
*of American Art, New York.*
A young, fashionably-dressed,
African-American woman steps
out of her home on a sunny
morning in the Carolinas. In
this, Hopper's only depiction
of an African-American woman,
the theme is similar to that
of *Summertime*. The open
fields, radiant with sunlight,
stretch far into the distance
and add a touch of warmth
to the composition.

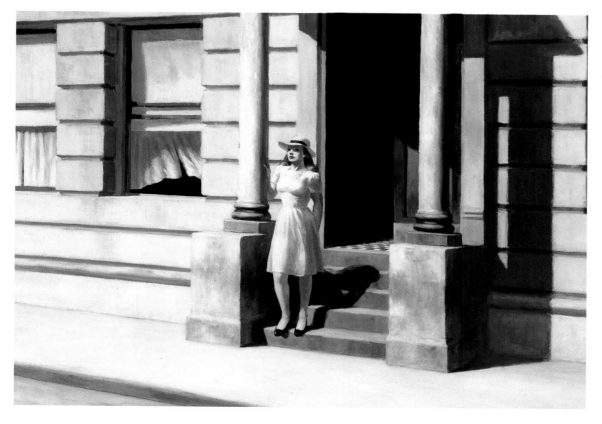

## Summertime

*1943, oil on canvas;*
*29 1/8 x 44 in. (74 x 112 cm).*
*Delaware Art Museum, Gift of*
*Dora Sexton Brown, Wilmington.*
Standing on the steps of her
apartment building, a young,
fashionably-dressed woman
appears to greet a glorious sum-
mer day. Completed in 1943,
shortly before the end of World
War II, Hopper's painting may
suggest the country's growing
optimism and period of prosper-
ity in the mid-to-late 1940s.
Additionally, the young woman's
burgeoning sexuality, perhaps
tied to the dearth of men
during the war years, is evident
in the transparency of her
dress and echoed by the curtains
blowing into the dark interior.

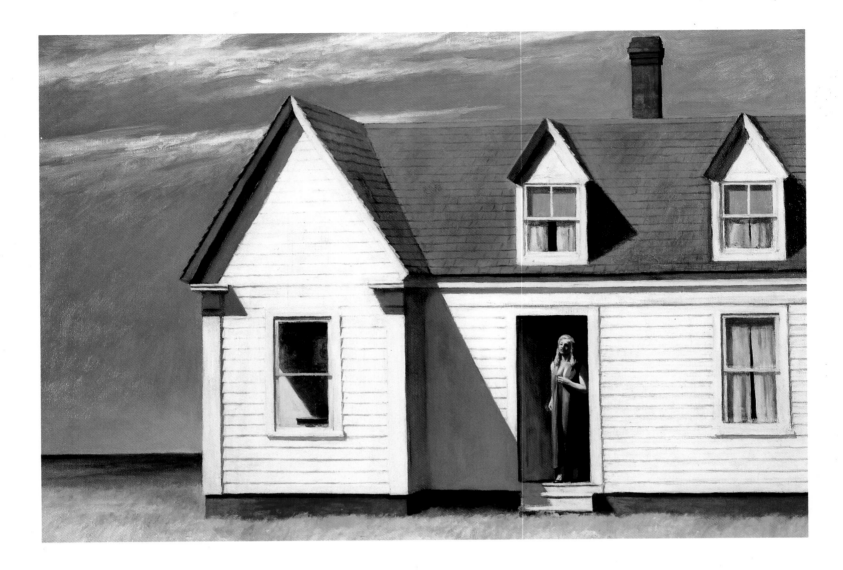

## High Noon

*1949, oil on canvas;*
*28 x 40 in (71 x 102 cm).*
*The Dayton Art Institute,*
*Gift of Mr. and Mrs. Anthony*
*Haswell, 1971.7, Dayton, Ohio.*
The provocative woman in this
work appears to be basking in the
sun by her open doorway. In the
1950's Hopper developed an interest
in light, in particular the sunlight
of Cape Cod. He was so determined
to capture the right intensity of
brightness in *High Noon* that he
built a cardboard model of the
house in the painting, and placed
it outdoors. Through observation
of this model, Hopper was assured
that he could capture the correct
amount of sunlight for his work.

surprisingly similar in tone to that of the surrealist work of the Belgian artist René
Magritte.

Hopper's subject matter of this period, however, was by no means limited to views from
his home. People experiencing the sun both indoors and outdoors was a predominant
theme of Hopper's late works. He was particularly interested in painting people sitting or
standing inside rooms filled with sunlight. In many of these pieces, such as *Cape Cod
Morning* (1950), the figures seem to be basking in a ray of sunlight streaming through a
window.

*In High Noon* (1949), a blond woman wearing a bathrobe stands by her open door bask-
ing in the radiant Cape Cod sunshine, which seems to assume a role far greater than its
physical reality. The sunlight appears to be linked to the woman's awakening sexuality.
Indeed, it highlights her ample breasts which can be glimpsed through the parted robe.
One could view this work as Hopper's modern Danaë. In representations of the mytho-
logical story of Zeus and Danaë, of which Hopper was well aware, Zeus appears as a
shower of radiant gold to rob the young nymph's virginity. Furthermore, the composi-
tional similarities between the rural scene in *High Noon* and the urban scene in
*Summertime* (1943) lead one to believe that the two works may have been pendants for
one another. Both works portray a sexually provocative younger woman stepping out into
a glorious summer day from a house with a shadowy interior.

Hopper also frequently painted pictures of people sunbathing, by now a popular pastime
on the Cape. In *Second Story Sunlight*, he depicted two generations of women, perhaps from

the same family, sunning themselves. Hopper referred to the teenage girl as "Toots," and as her name suggests, she is, in contrast to the older woman, bursting with sexuality and life. Sunbathing is the topic of *People in the Sun* (1960) as well. With their chairs facing into the sun, the five figures appear to be merely sunning themselves, and yet at the same time their experience seems more akin to a spiritual awakening than a leisure activity.

Hopper's use of sunlight in his late works as a metaphor for transcendental revelation is best exemplified by *Excursion into Philosophy* (1959). In this painting, a man seated on a bed with an open book beside him contemplates a spot of sunlight on the floor. A woman lies on the bed next to the man—her back turned away from the viewer. In Hopper's ledger books, Jo interpreted the composition as follows: "The open book is Plato, reread

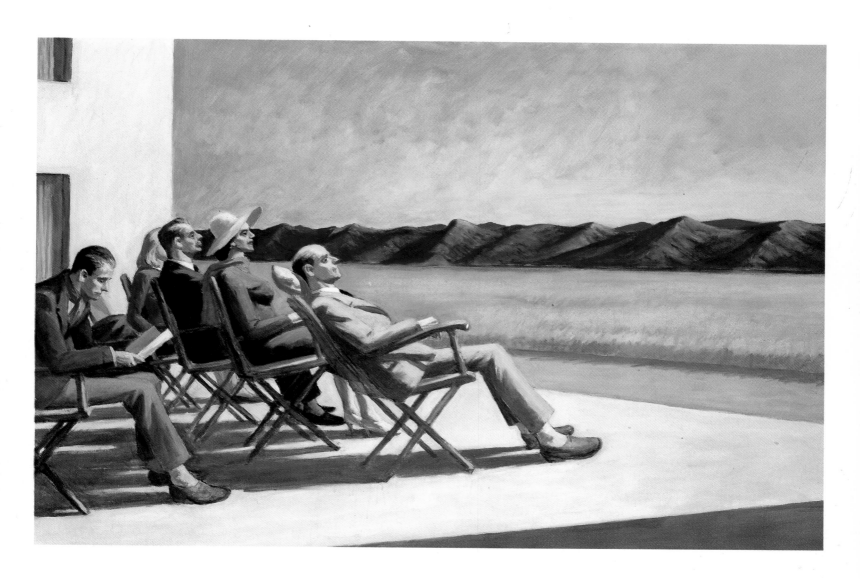

## People in the Sun

*1960, oil on canvas; 40 x 60 in. (102 x 152 cm).*
*National Museum of American Art, Smithsonian, Washington D. C.*
The nationally popular pastime of sunbathing must have appealed to Hopper because it allowed him to explore two elements important to his art: the play of light and the portrayal of people. In this work he presents a crowd of people basking in the sun. As is to be expected in Hopper's work, none of these individuals interact with one another. While particpating in the same activity, their leisure time is not to be shared.

*Following page:*
### Cape Cod Afternoon
*1936, oil on canvas; 34 3/16 x 50 1/16 in. (87 x 127 cm).*
*The Carnegie Museum of Art, Pittsburgh.*
Hopper's interest in painting specific times of day resulted from his enthusiasm for the French Impressionists. In this work, Hopper combines one of his favorite subjects, Cape Cod architecture, with the interplay of sunlight. He managed to capture the beauty of a summer afternoon in this rendering of simple structures, such as this farmhouse which is typical of those commonly found on the Cape.

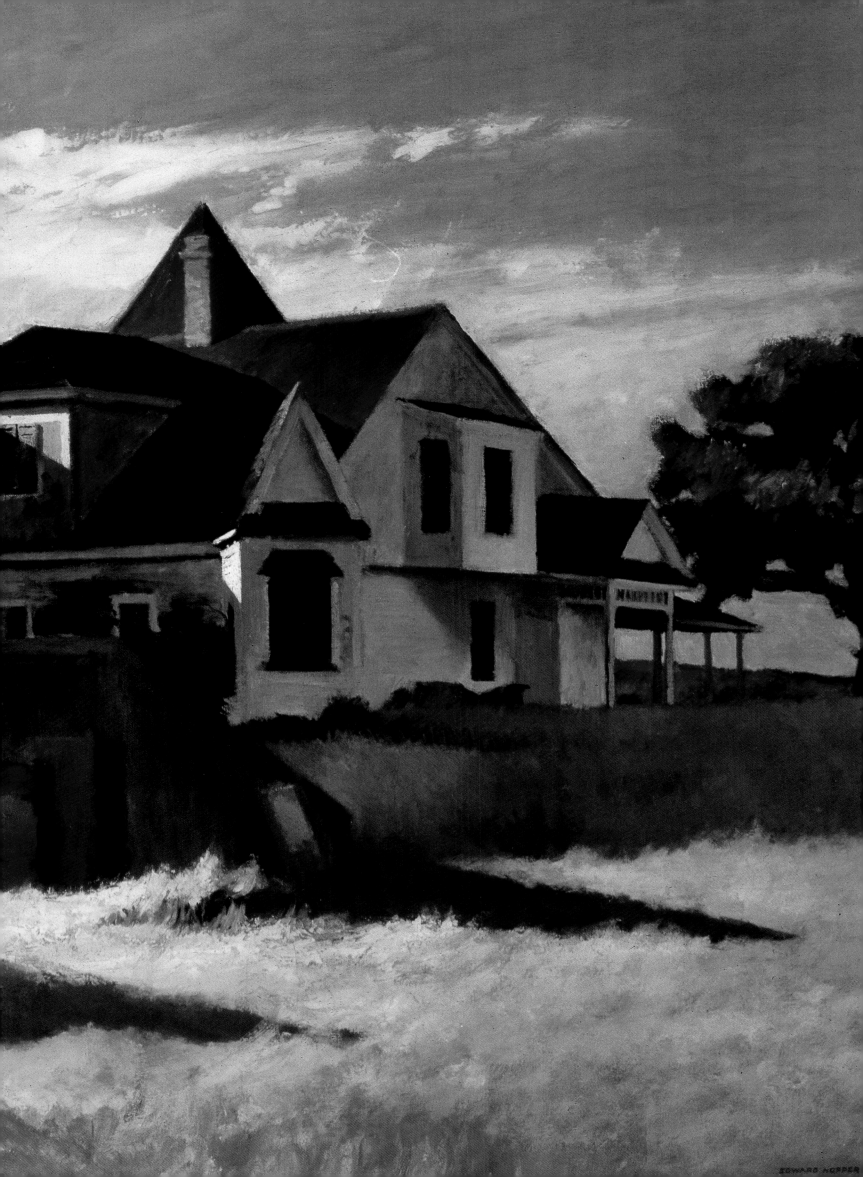

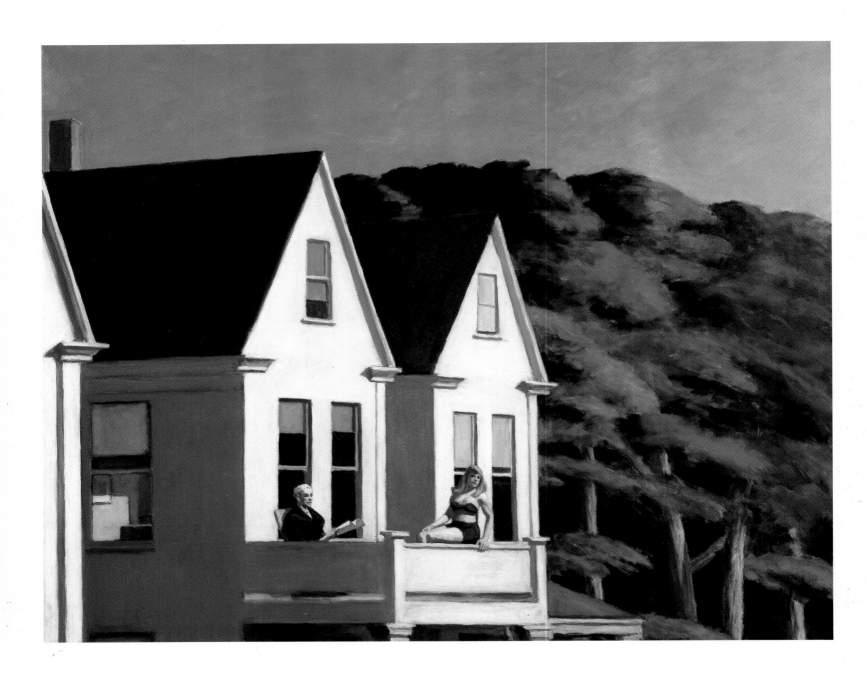

## Second Story Sunlight

*1960, oil on canvas; 40 x 50 in. (102 x 127 cm).*
*Collection of Whitney Museum of American Art, New York.*
Hopper often denied that there were any hidden meanings in his works. His stated intention in this painting was to recreate the effect of white sunlight on the upper portion of a house on Cape Cod. When the critic James Thomas Flexner described the work as an allegory of the seasons and of life, Hopper responded, "It may indicate that I am not as modest as I am said to be."

too late." The allusion to Plato is, according to Hobbs, a reference to the Neoplatonic argument and the philosophic question of whether objects in this world are real, or merely shadows cast by or ideas reflected from a higher reality. The man in *Excursion into Philosophy* appears to be debating the reality versus the idea of the patch of light.

While Hopper's late works are resplendent with sunlight, it is important to note that his mature themes of alienation and isolation persist even in these pieces. Ironically, the depiction in these paintings of warm rays of sun and the people basking in them does not alleviate the sense of disconnectedness in his compositions. For example, Hopper's use of cold wintry colors in many of the aforementioned works conveys a sense of utter desolation.

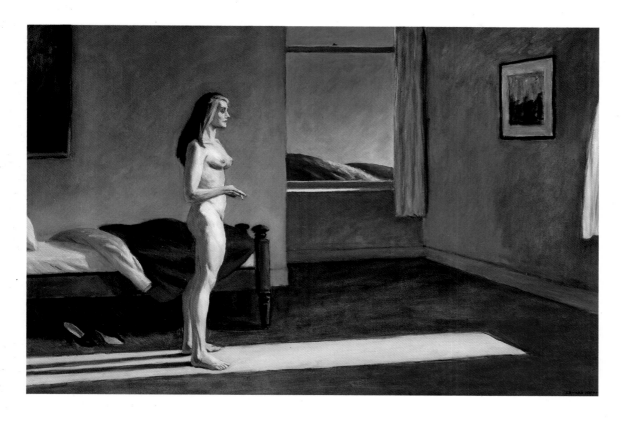

### A Woman in the Sun

*1961, oil on canvas;*
*40 x 60 in. (102 x 152 cm).*
*Collection of Whitney Museum*
*of American Art, New York.*
In this work the viewer is
confronted with a sparsely
furnished room, containing
a single bed and two hanging
pictures. A middle-aged
woman stands in the sunlight
with a cigarette in her hand.
She faces the window, the
source of the light. Perhaps, as
the flung covers on the unmade
bed suggest, she has just awak-
ened and is contemplating
the day ahead. Hopper was
fascinated by the rectangular
shapes and shadows caused by
sunlight streaming into rooms.

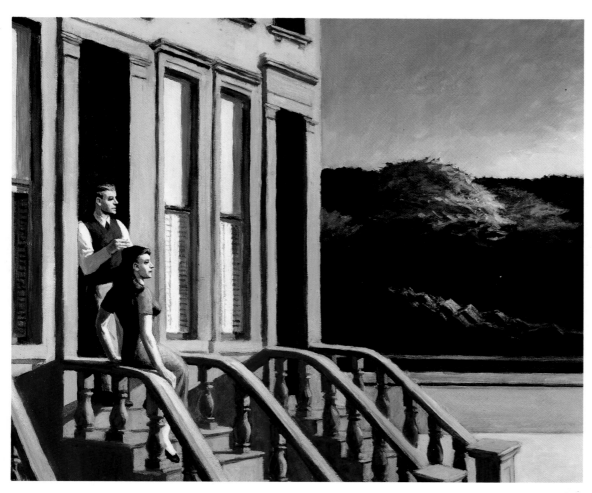

### Sunlight on Brownstones

*1956, oil on canvas;*
*30 3/8 x 40 1/8 in.*
*(71 x 102 cm).*
*Wichita Art Museum,*
*The Roland P. Murdock*
*Collection, Wichita, Kansas.*
Here we see the stoops
of a row of brownstones,
where a man and woman
gaze out into the distance
perhaps wishing to be
elsewhere. Hopper effectively
captures the boredom of
this couple on a hot summer's
day. Ironically, the warmth
of the sun does not lessen
the emotional distance
between the couple.

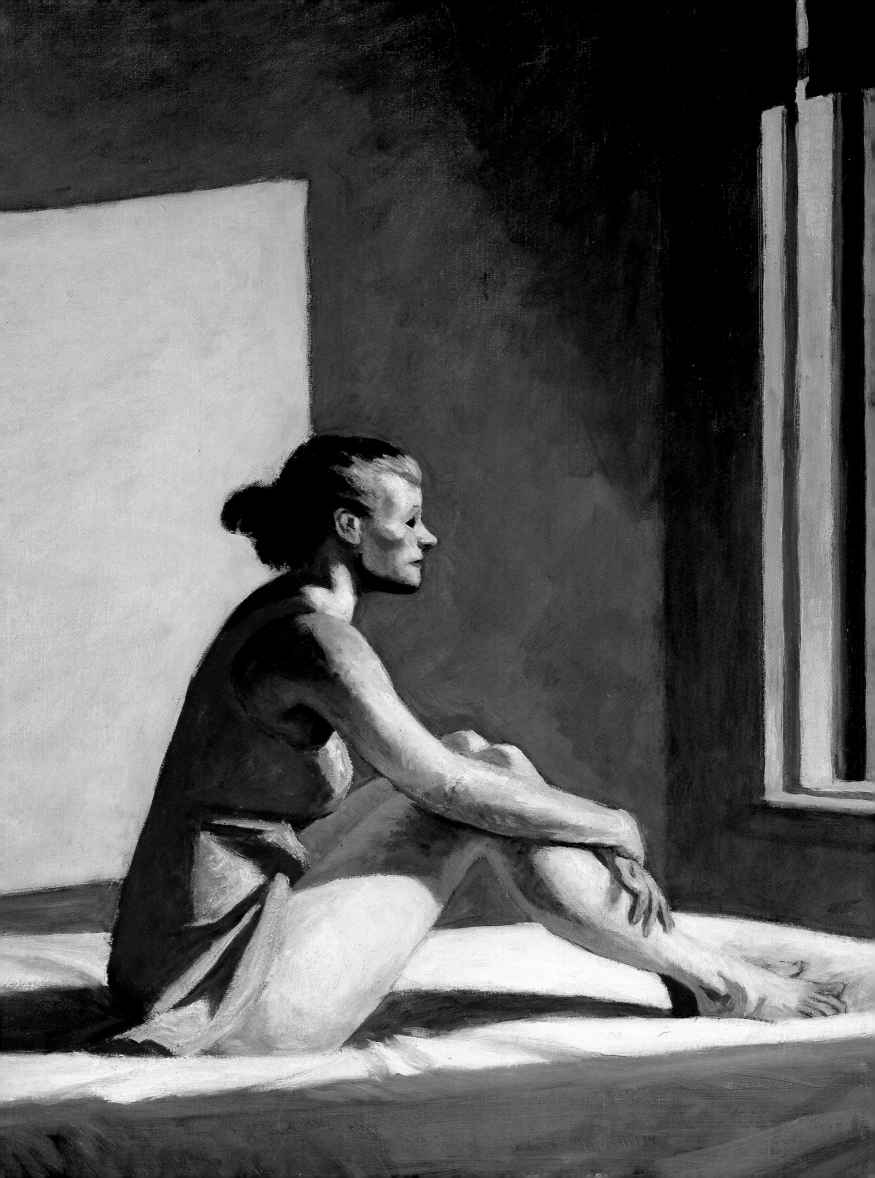

## Sunlight in the City

Hopper's interest in light in his late works extended beyond the images inspired by Cape Cod. His city scenes of this period also reflect a fascination with sunlight. Though *Morning Sun* (1952) recalls the subject matter of Hopper's earlier piece *Evening Wind* (1921), its style is characteristic of that of his late works. In *Morning Sun*, a woman seated on her bed looks out an open city window while sunlight streaming in warms her face and body. Hopper may have been employing symbolic motifs in his late paintings in order to incorporate added meaning. As Hobbs has speculated, light in a room could have been a reference to the soul and its spiritual awakening. With his advancing age, Hopper, like artists of the past, may have been exploring the meaning of life beyond its physical existence.

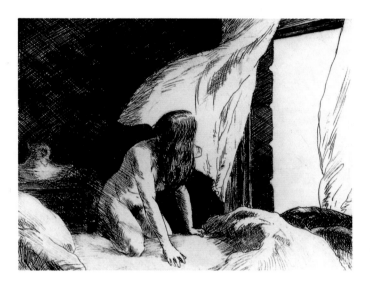

### Evening Wind

*1921, etching; 6 7/8 x 8 1/4 in. (17 x 21 cm).*
*Collection of Whitney Museum of American Art, New York.*
This work is a precursor to many of Hopper's later paintings of a lone figure by a window. When it was exhibited at the National Academy of Design, one critic wrote that Hopper had "a genius for finding beauty in ugliness."

### Morning Sun

*1952, oil on canvas; 28 1/8 x 40 1/8 in. (72 x 102 cm).*
*Columbus Museum of Art, Ohio.*
The reemergence of Hopper's interest in sunlight in the 1950s also extended to his city scenes. In this work a woman, perhaps having just arisen from sleep, stares out into the morning sunlight. Hopper was fascinated with the patches of abstract shapes that resulted from the play of light on surfaces.

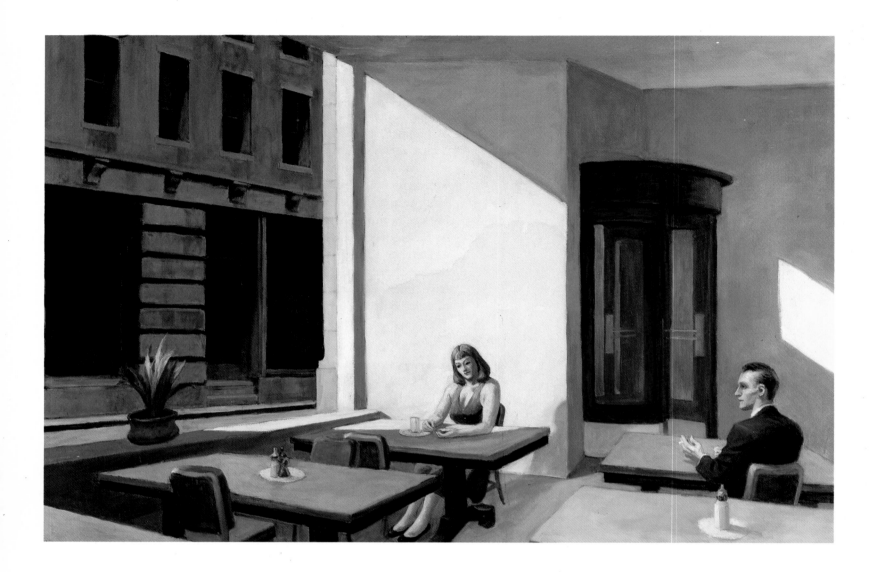

**Sunlight in a Cafeteria**

*1958, oil on canvas;*
*40 1/4 x 60 1/8 in. (102 x 153 cm).*
*Yale University Art Gallery, New Haven.*
Lack of communication between the
sexes is explored in this view of a cafeteria. Aware of each other's presence, a
man and a woman sit at separate tables
in a room filled with sunlight. The
man smokes a cigarette and gazes
out the window, while the woman
looks down at her coffee cup, deep
in thought. What should in fact be a
natural interaction between people has
become impossible. Hopper recognized
the nature of city life and the loneliness
an individual can feel among strangers.

Although dominated by light, Hopper's *Sunlight on Brownstones* (1956) and
*Sunlight in a Cafeteria* (1958) once again project the recurring theme of alienation. In the earlier work, *Sunlight on Brownstones*, Hopper captures the boredom of a young couple on a summer's day. The man and woman stand on the
steps of a brownstone looking out into the distance, perhaps wishing to be
elsewhere. There is no sense of interaction between the two. Moreover, the
sunlight which bathes the couple actually serves to create the frozen stillness
of the composition.

The sense of isolation is even greater in *Sunlight in a Cafeteria*. In a sun-filled
cafeteria, a man and woman sit at separate tables. The man's cigarette and the
phallic sugar container are, according to Hobbs, symbolic of the sexual tensions
between these strangers. Their separation from one another is again compounded by the warm sunlight. The rays of the sun form an insubstantial but evident
barrier between the two.

## The Final Years

As Hopper only painted one or two works each year toward the end of his life,
it is difficult to ascribe a particular style to this period. Hopper's interest in sunlight continued, yet his predilection for realism seemed to sway a bit.
Consequently, the brushstrokes and paint texture are slightly more visible in
*New York Office* (1962), *Intermission* (1963), and *Chair Car* (1965). The women in

these three paintings also appear to be far more victimized by the alienation of modern life than those in his earlier works.

Hopper executed his final piece, *Two Comedians*, less than two years before his death in 1967. By 1965, the artist was already ill and, perhaps, aware of his impending death. The painting is Hopper's final farewell to the audience and critics who had followed him faithfully for so many years. Set on a stage, it depicts "two small figures out of pantomime" taking their last bows. According to Jo, the two comedians were meant to be representations of herself and Hopper.

*Two Comedians* can be interpreted as affirming Hopper's view of the theater as a model for the creation of his art. Levin insightfully wrote,

> Hopper, it seems clear, saw the theater as a metaphor for life, and himself as a kind of stage director, setting up scenes to paint based on events he saw take place around him, casting his characters from types he observed....Even in his habit of having Jo pose for all the women he painted, he acted like a director giving a favorite actress many roles to play.

As is not uncommon with couples who have been together for decades, Jo died a year after Edward in 1968.

In a career that spanned the greater part of the twentieth century, Edward Hopper created in paint some of the greatest dramas of life in modern America ever to be recorded. His universal theme of the alienation of the individual within society is as relevant to today's viewers as it was to Hopper's contemporaries. Hopper, however, never set out to depict universal themes; he simply painted his impressions of what he saw. Indeed, as the artist himself explained, "My aim in painting has always been the exact transcription of my most intimate impressions of nature... I have tried to present my sensations in what is the most congenial and impressive form possible to me. The technical obstacles of painting perhaps dictate this form. It derives also from the limitations of personality. Of such may be the simplifications that I have attempted."

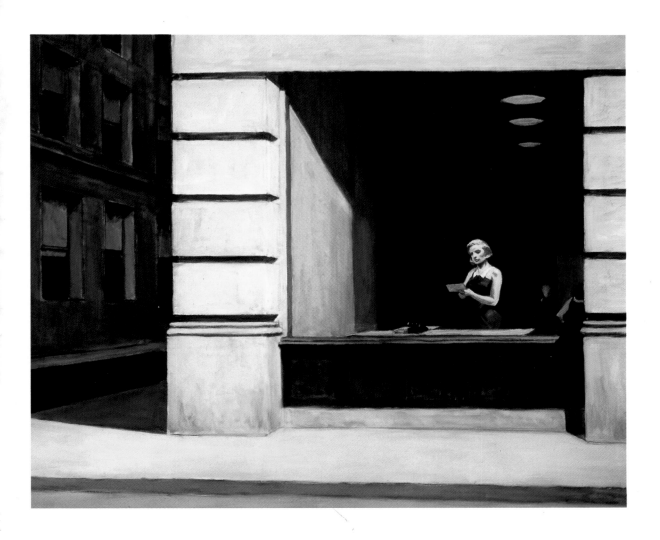

**New York Office**
*1962, oil on canvas;*
*40 x 55 in. (102 x 140 cm).*
*Collection of the Museum*
*of Fine Arts, Montgomery,*
*Alabama; The Blount*
*Collection.*
A woman in an office looks out of the window at the street. Like the man in Hopper's earlier painting, *Office in a Small City*, the woman is a victim of her circumstances. Dramatic lighting resulting from the concentration of brilliant sunlight on the front of the building lends a theatrical touch and reveals the woman's role as an object for the voyeur.

# INDEX